I can only tell you what my eyes see
Giles Duley

SAQI

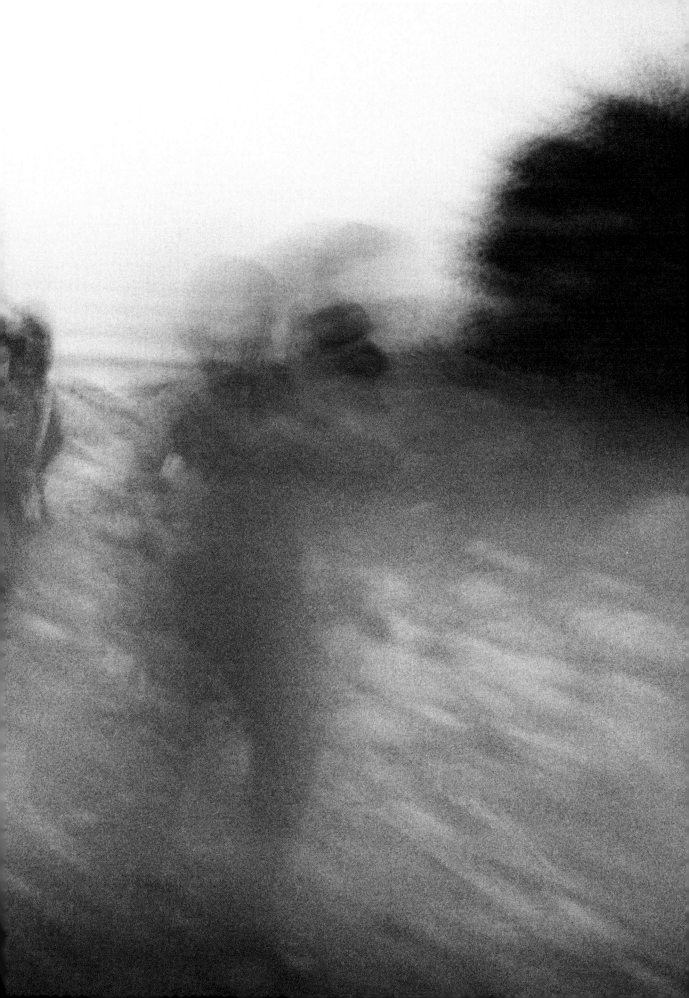

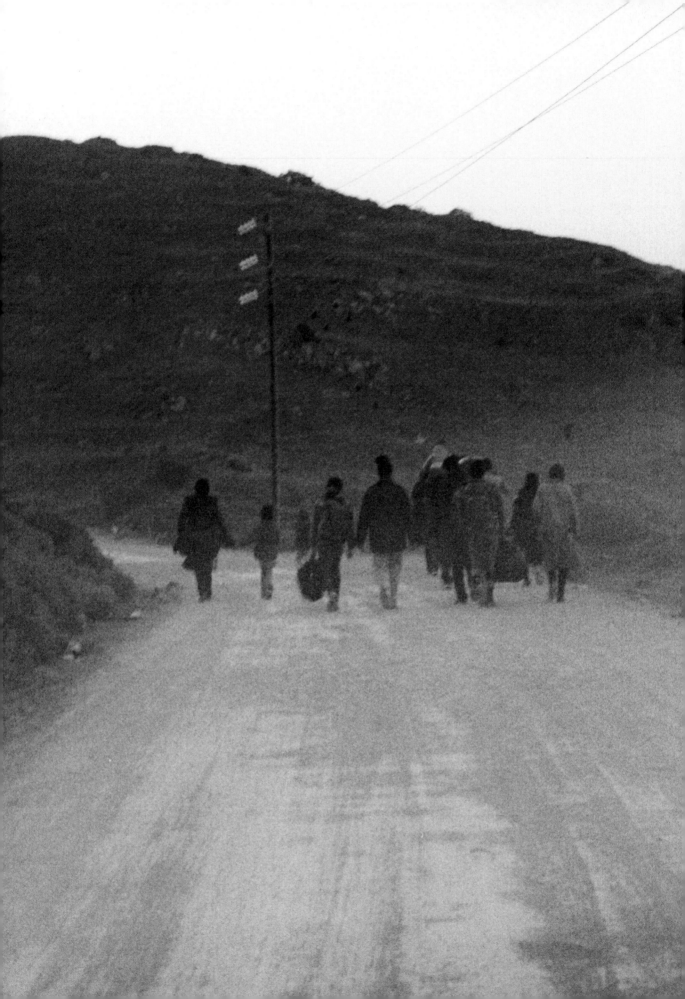

'*Shefna el mot bi oyouna*'
'We saw death with our own eyes'

For Aya and Khouloud

Filippo Grandi

Foreword

For most people, a refugee crisis happens out of sight. It might be glimpsed in a newspaper headline or on a television screen, or heard in a politician's speech or parliamentary debate. But for many, refugees are an abstract concept – another news report, the by-product of a geopolitical struggle, a set of grim statistics.

The statistics are hard to comprehend. Our latest count found that there are 21.3 million refugees globally; as with every year of the past decade, our next official count will no doubt give a higher figure. More than half of those refugees are under the age of 18. Every day, tens of thousands of people are forced to flee their homes because of conflict and persecution, adding to the 65 million people who have already been displaced – internally, within their own countries, or across borders as refugees. That is roughly the equivalent of the population of the United Kingdom. The vast majority of refugees – some 90 per cent – remain in their own regions, generously hosted by countries often struggling to meet the needs of their own citizens.

But in 2015, a million people attempted to cross the Mediterranean Sea to reach Europe, half of them Syrians fleeing a conflict that is getting inexorably worse. Thousands lost their lives, crammed onto unseaworthy boats with insufficient fuel and no means of navigation or communication. Yet hundreds of thousands survived. We asked Giles Duley to record their stories. He has done so with unflinching honesty and boundless humanity.

Turn these pages and you will discover that refugees are people like you and me. You will see the reality of families emerging from the sea, of flimsy flotillas reaching land. You will see men, women and children dressed as if they are on their way to work or to school. Fleeing the violence of war, they prepared for what they thought would be their entry into a more humane world. Yet they find themselves instead standing on a rocky shore or following a railway track in search of refuge. A child in jeans and an anorak; a man in an old favourite jacket; a woman in her best and warmest coat. Duley has pictured their encounters with a new reality – that of life as refugees – walking, grieving, playing, resting, questioning, teaching, thinking. Trying to survive, seeking ways to rebuild their lives. The result is a collection of images of powerful and arresting intimacy.

I found the images in this book strongly evocative of previous European crises: Yugoslavia in the 1990s, the refugees fleeing Hungary in 1956, and even the mass displacement of millions of people during and after the Second World War – people whose protection was the very reason for the establishment of UNHCR. Providing protection to people seeking refuge is a critical aspect of the identity of post-war Europe and of its foundationalvalues – and Europe has played a key role in transmitting and embedding those values at a global level.

Throughout 2015 and 2016, and especially during the months when Duley was engaged on his project, Europe woke up to the world's refugee crisis. At the same time, many Europeans somehow misplaced those fundamental values, seeking to portray refugees and migrants as a threat – to jobs, to security, and even to Europe's values and identity.

But many ordinary people have risen to the challenge, offering hospitality, solidarity and support, sharing their schools, hospitals and homes. Some governments have paved the way in demonstrating that if refugees are welcomed, and given access to education, opportunities and support to integrate, they will become assets to the communities that have embraced them.

In this era of large-scale displacement and impersonal statistics, Duley's photographs remind us that the numbers represent individual men, women and children. Recognising and acknowledging their humanity are the first steps towards action to end their suffering. If we deny them shelter and support, then we are failing to meet one of today's defining global challenges.

Perhaps the most inspiring element of Duley's work is that he is not a passive spectator documenting lives, the pain of lives torn apart. One can feel through his photographs that he is deeply touched by their courage and their resilience. We need more people like Giles Duley to stand together with refugees – no matter where they are in the world.

Filippo Grandi is the UN High Commissioner for Refugees.

Robert del Naja

In this Together

For years we have used our live shows to try and engage with the big global political issues of our time. Nothing we have done so far, though, has felt as powerful as sharing Giles' photographs of refugees as we did with our audiences in 2016. Our tour became a platform for positivity and empathy, showing solidarity where little could be found in the mainstream media.

We live in uncertain times, a so-called post-truth era, where armies of trolls are paid to pollute social media with fake news and misinformation. All too easily we also become unwitting propaganda merchants ourselves, sharing our opinions publicly, no matter how careless or factually incorrect.

Politicians seem powerless to make decisions, and any display of moral leadership is met with mistrust. In order to serve the public interest, the media amplifies the situation, yet struggles to present the facts. In 2016, the (Syrian) refugee crisis became a casualty of these factors. As a band we were left questioning: how do we respond to real issues?

In 2015, Giles began sending me photographs – live, direct and most importantly, unfiltered – from the beaches, borders and makeshift camps he was documenting. Through his eyes I became an uncomfortable witness to some of the most intimate and life changing moments. It was humbling, and powerful, and something I couldn't turn away from. Later on, as his project developed, he sent me the portraits that he was working on in the camps. By redacting the environment and difficult conditions, he attempted to honour the dignity of his subjects, reminding us that we are no different from one another. It was these simple portraits that we used in our shows during the summer of 2016, their clear empathy reminding us of our shared humanity.

This book documents a time when people are forced to evacuate their homelands because of war and oppression; scenes that belong to a previous era, scenes we thought long past. Yet they are happening today. These photographs also serve as a witness to a time when the international community is no longer willing or able to help, possibly because none of us know what to believe anymore. Giles has been able to tell us their stories, uncontaminated by editorial narrative and opinion, giving us just truth and reality.

Robert del Naja is an artist, musician and founding member of the band Massive Attack.

Giles Duley

I Can Only Tell You What My Eyes See

There is no such thing as truth in photography. As soon as I enter a room, I choose to point my camera in a certain direction, and when I press the shutter, I have decided on that moment at the exclusion of all others. So how can there be a truth in that?

With the refugee crisis, there can be no definitive moment, no single image that tells all. The refugee crisis is a million stories woven together into a tapestry that reads differently depending on where you stand. And I think it's important that we see it that way; its complex, its multi-layered and we have to avoid the trap of bundling this into one story and one truth. In doing so, we don't do justice to those whose lives are caught up in this crisis.

In late December 2015, Idomeni, the border crossing between Greece and the Republic of Macedonia (FYRM), was closed. Over two thousand refugees, asylum seekers and migrants found their route ahead blocked. Tensions were rising as people grew more desperate. Finally there was a confrontation between those trying to cross and the police who blocked their route. Rocks were thrown, teargas fired. As protestors pushed against the fences, the world's press was there to capture the drama.

Yet this represented fewer than 200 people in a camp of over 2000. The majority were themselves taking shelter in makeshift tents. As the riots started, I sat in a tent drinking tea with a Yemeni family who were terrified of the rioters and, throughout the night, as I wandered around the camp, families approached me asking for safety from the violence.

Of course the next day the papers were full of photos of the riot, with no mention of the majority of the people who'd been forced to shelter from it. What is the truth? The media will always focus on the dramatic, which means we often don't see the full picture. For the majority of refugees, their journey, their story, is never told.

And equally my photographs and work don't present the truth, but they do attempt to show another side. Away from the dramatic, my work focuses on the banality of everyday life, especially for families stuck in the limbo of camps in Jordan, Iraq and Lebanon.

When the UNHCR approached me to document refugee stories across Europe and the Middle East, they gave me the greatest brief. It was simple: they asked me to follow my heart. And over the coming seven months, that is what I tried to do.

For over a decade I have documented the effects of war on civilians around the globe. From South Sudan to Bangladesh, Afghanistan and Angola, it is the stories of refugees that have mostly been my focus. From the start of the conflict in Syria, I have witnessed the growing crisis in Jordan and Lebanon. Yet despite all this, nothing had prepared me for the months on the road and the hundreds of stories I listened to. Travelling to over a dozen countries I got a sense of the enormity of this crisis. Focusing on refugees from Afghanistan, Iraq and Syria, I saw the effects of decades of war that were creating a diaspora from shattered nations, civilians forced from their homes looking for shelter across the globe.

I have seen war. I have witnessed its effects first hand and I know why people flee. It's a simple question to ask, but what would we do in similar circumstances? To see your friends die, your families living in fear, jobs gone, schools closed, hospitals bombed – at what point would you decide to give up and flee? What has always astounded me is not that the refugees I met fled their homes, it's the fact that they endured so long before doing so.

I can honestly say that throughout this project, I never met one refugee who had a sense of victory that they had made it to Europe, Lebanon or Jordan – a sense of relief maybe, but never jubilation. Instead, each bore a longing and wish for home. These are people who endured to their limit, and only when all options had gone, they took the hardest decision – to become a refugee.

I can't tell you what it is like to be a refugee; I can't speak for the people of Syria, Iraq and Afghanistan. I can only bear witness. Earlier I said that I question if there is such a thing as truth in photography, and I do doubt that. However, I do believe there can be honesty, honesty in representing what we witness in as balanced a way as we can. To the best of my abilities I have tried that, for as a photographer I can only tell you what I see.

PART I

The Journey:
Lesvos to Berlin

Sep–Dec 2015

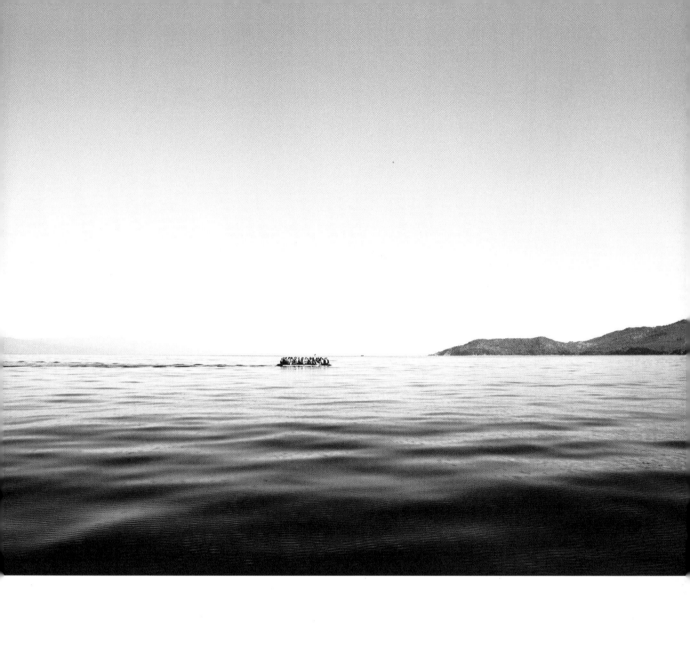

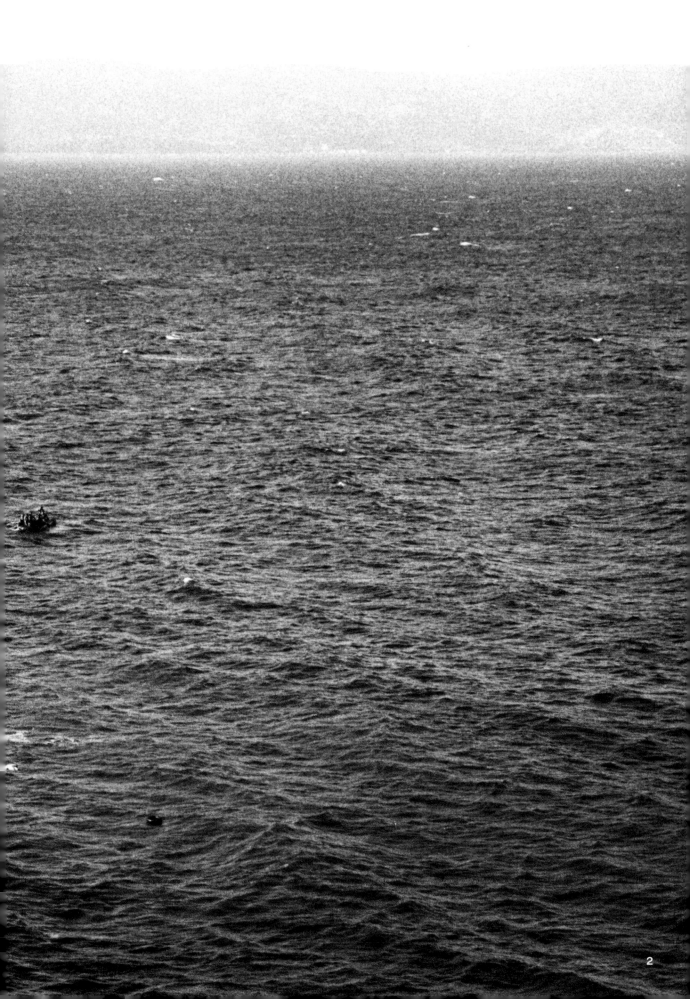

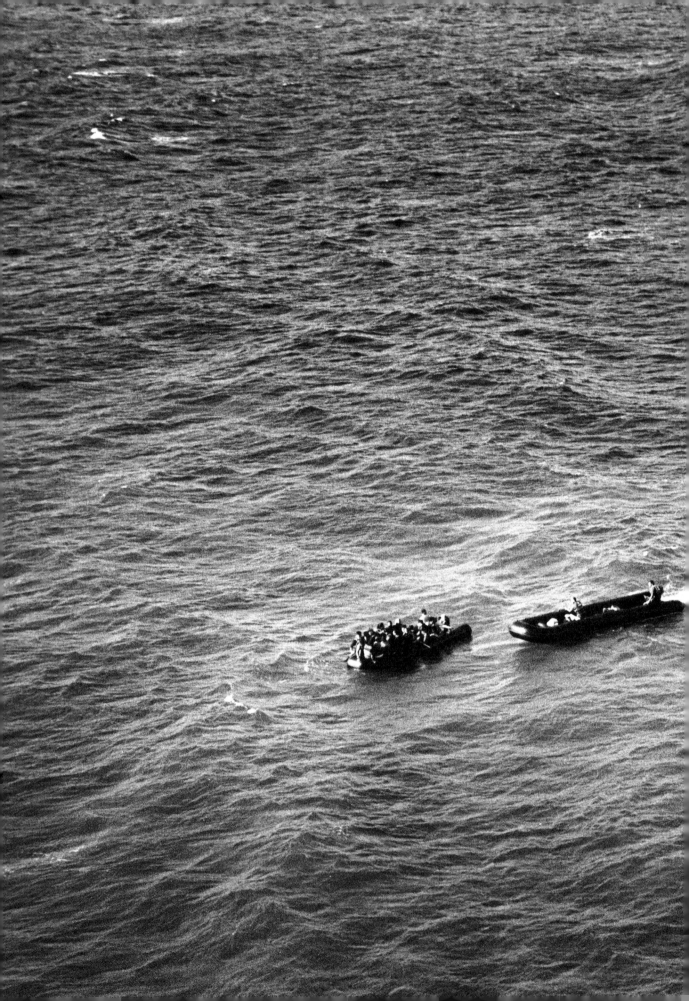

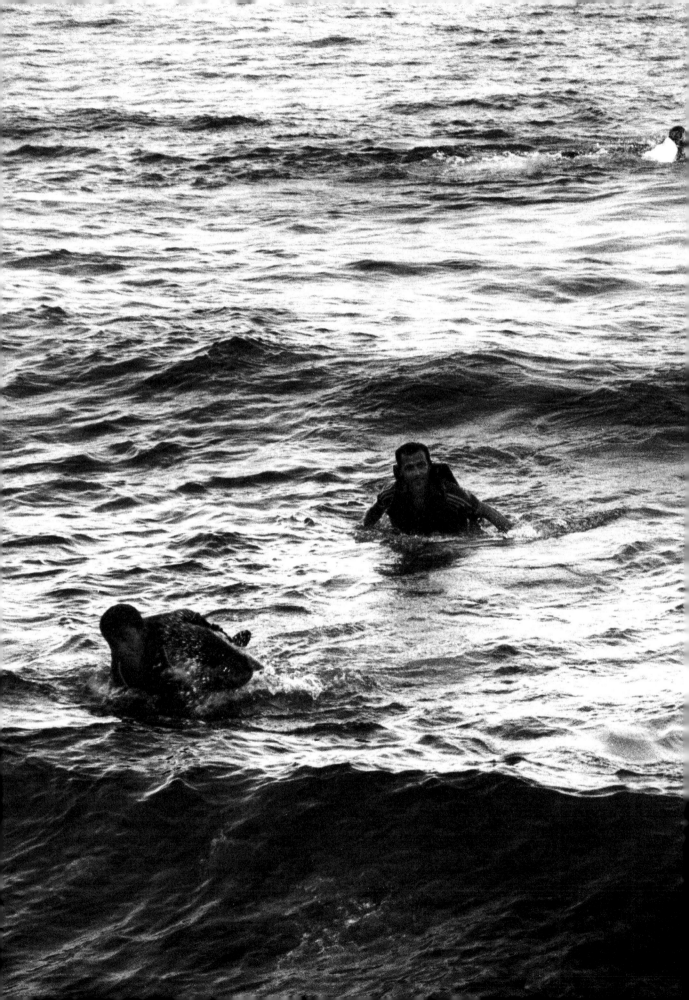

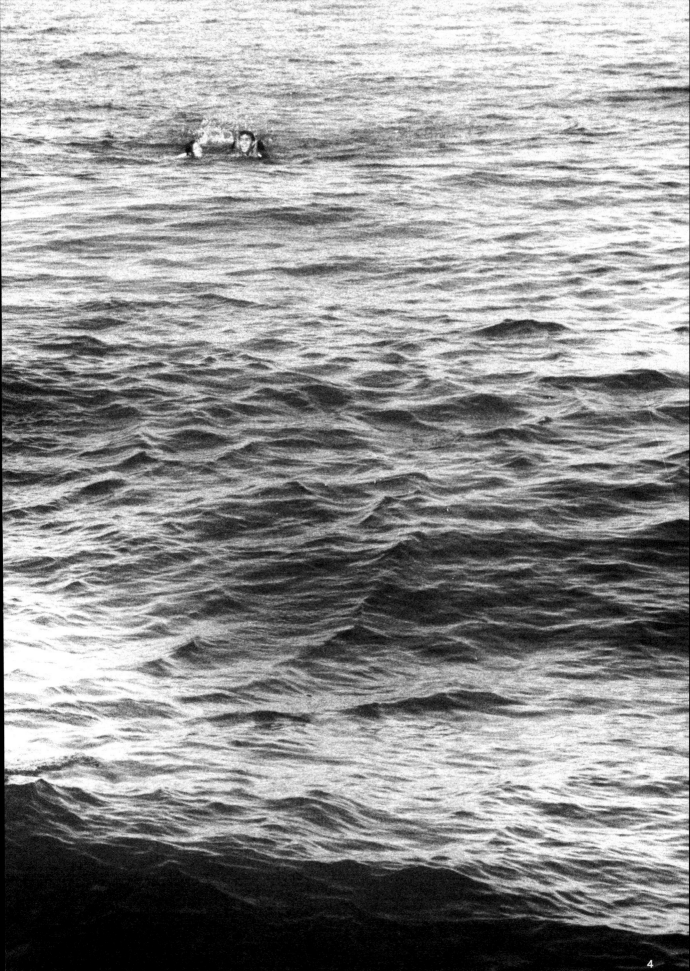

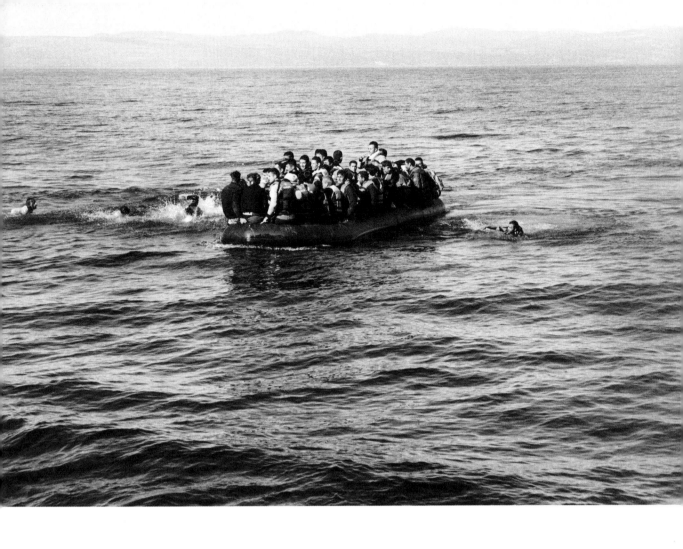

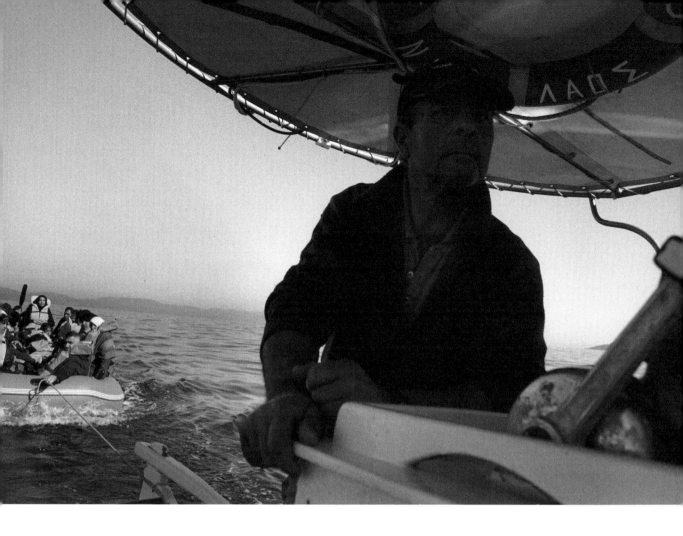

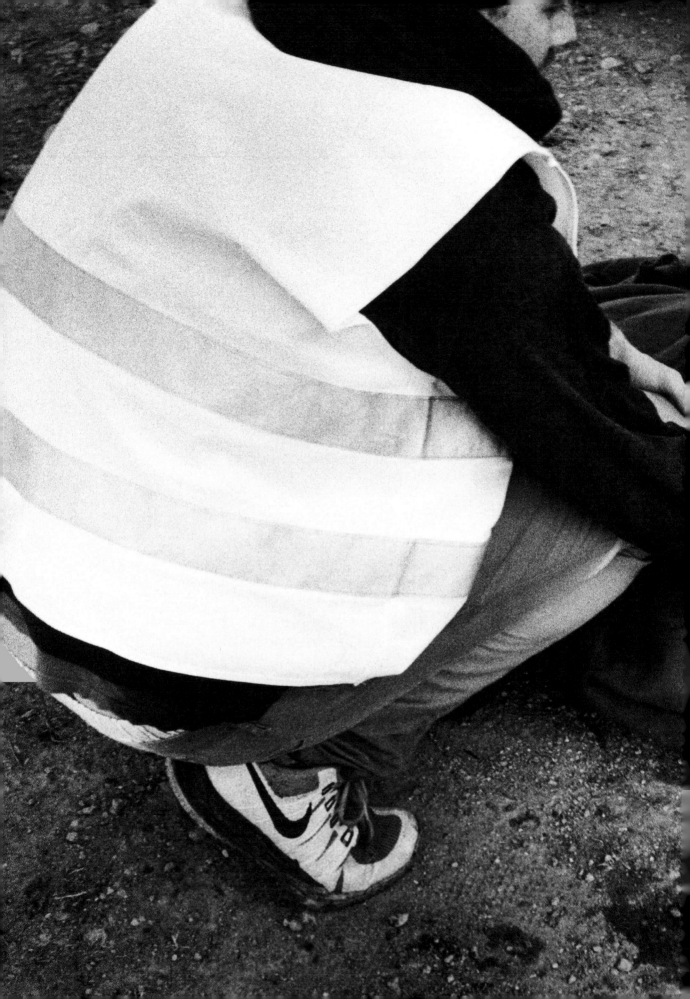

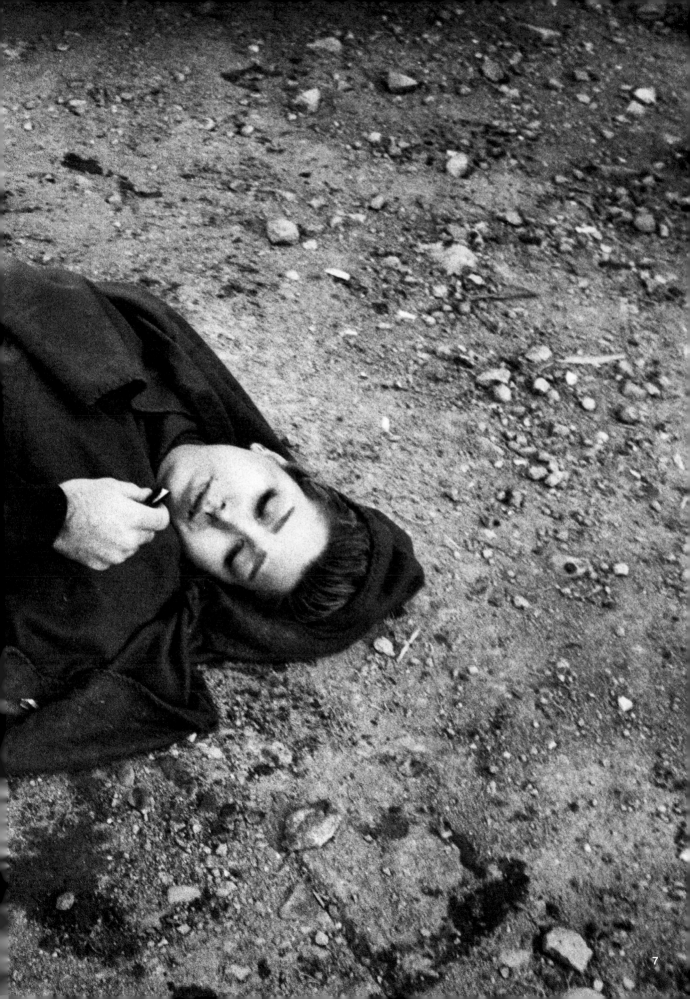

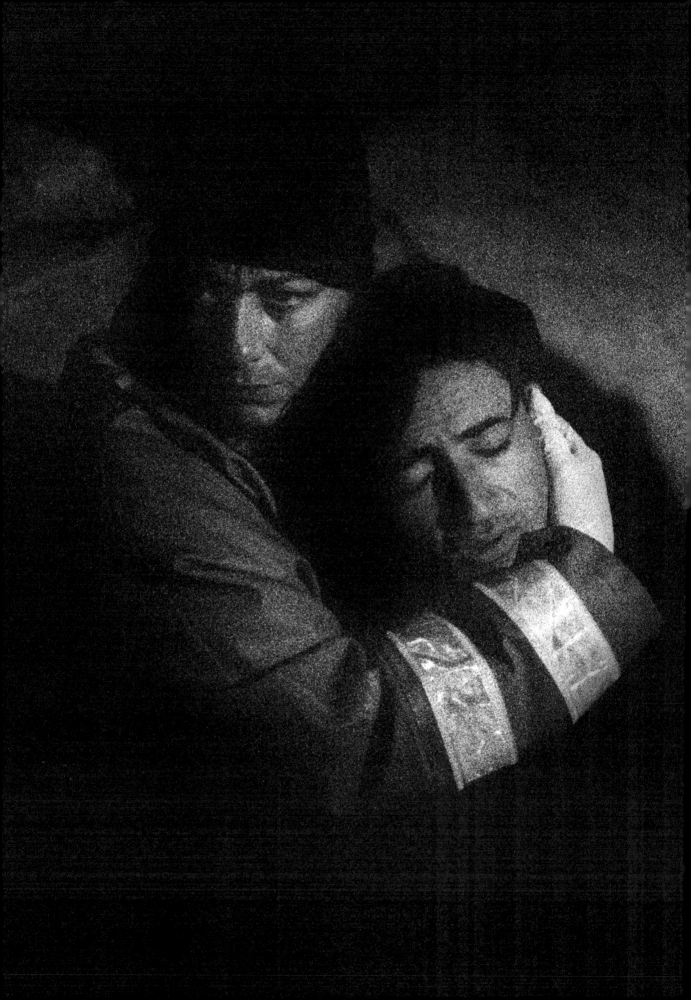

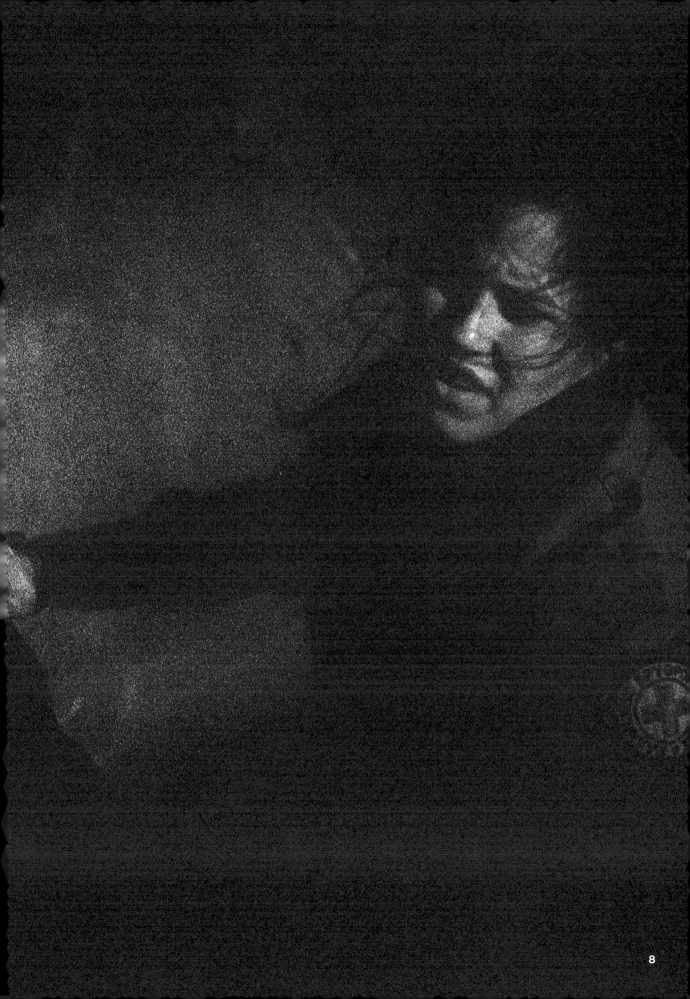

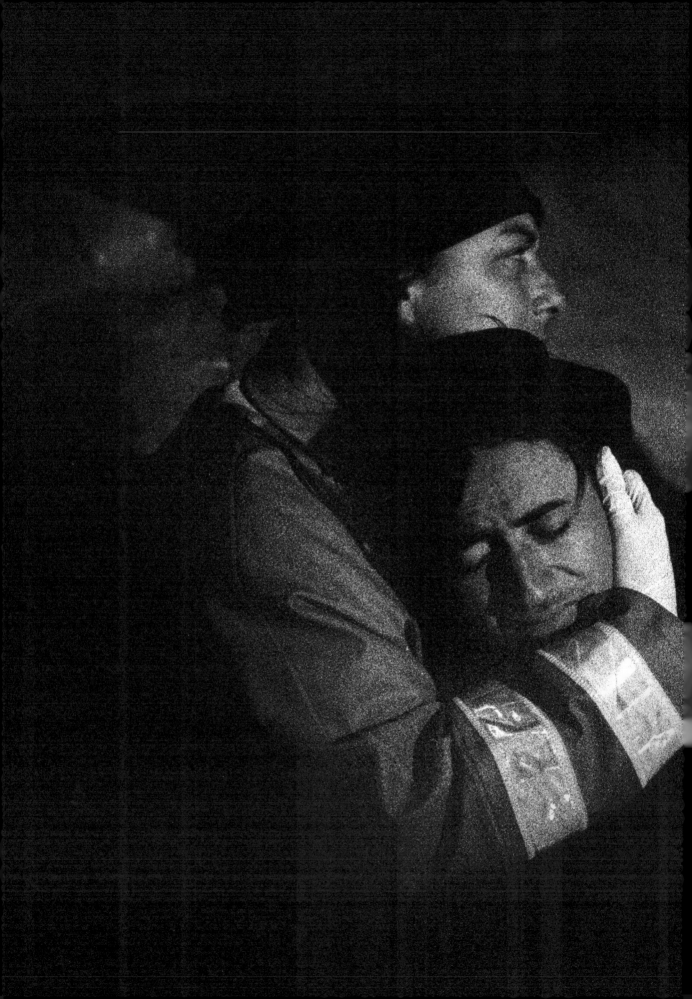

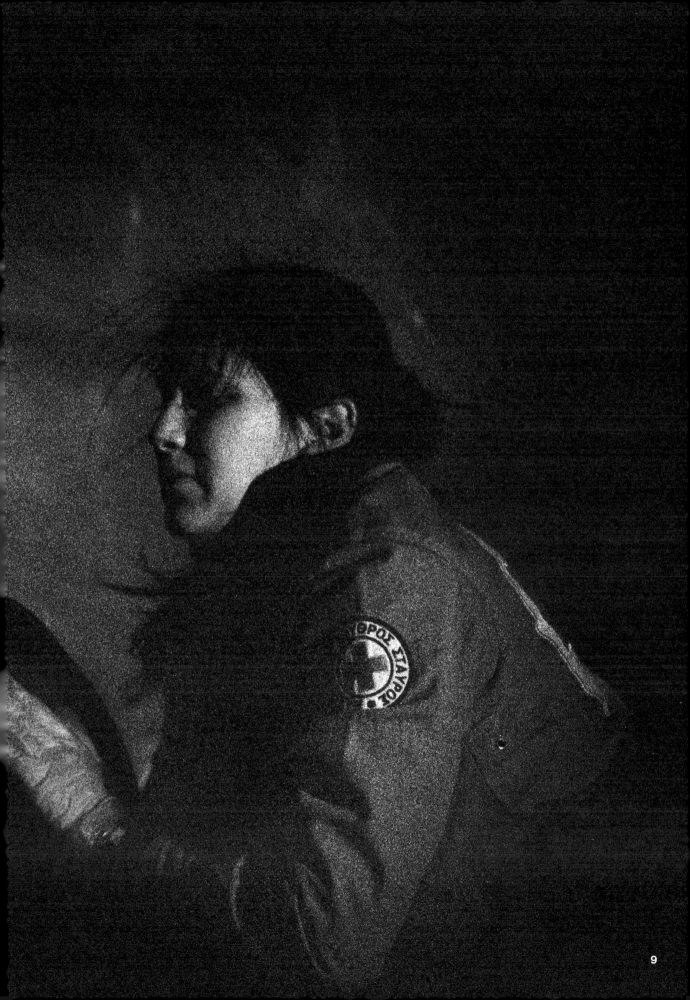

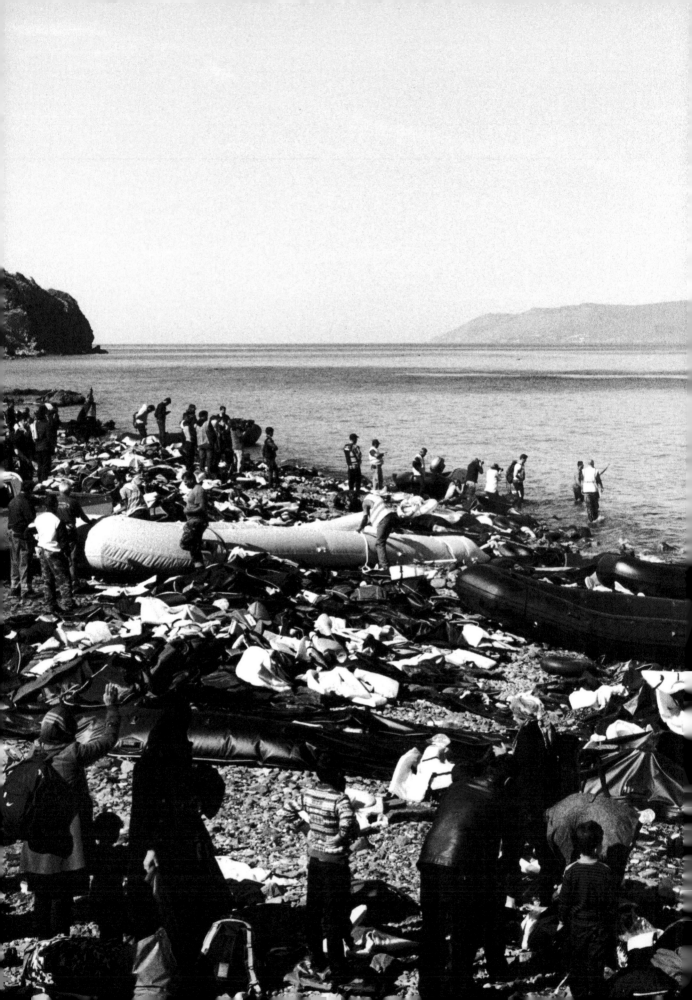

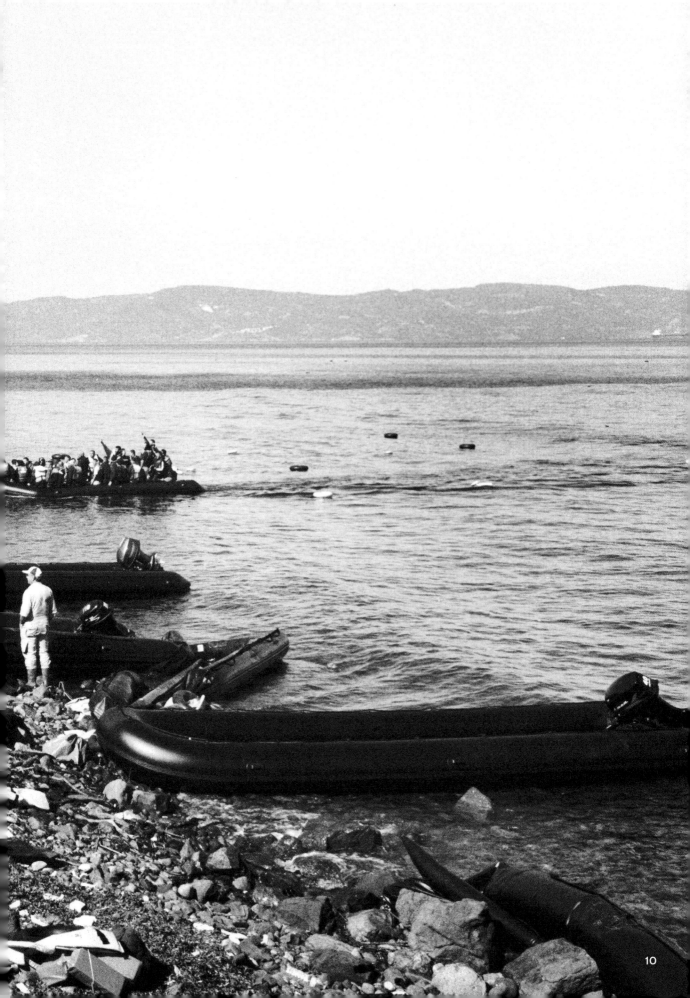

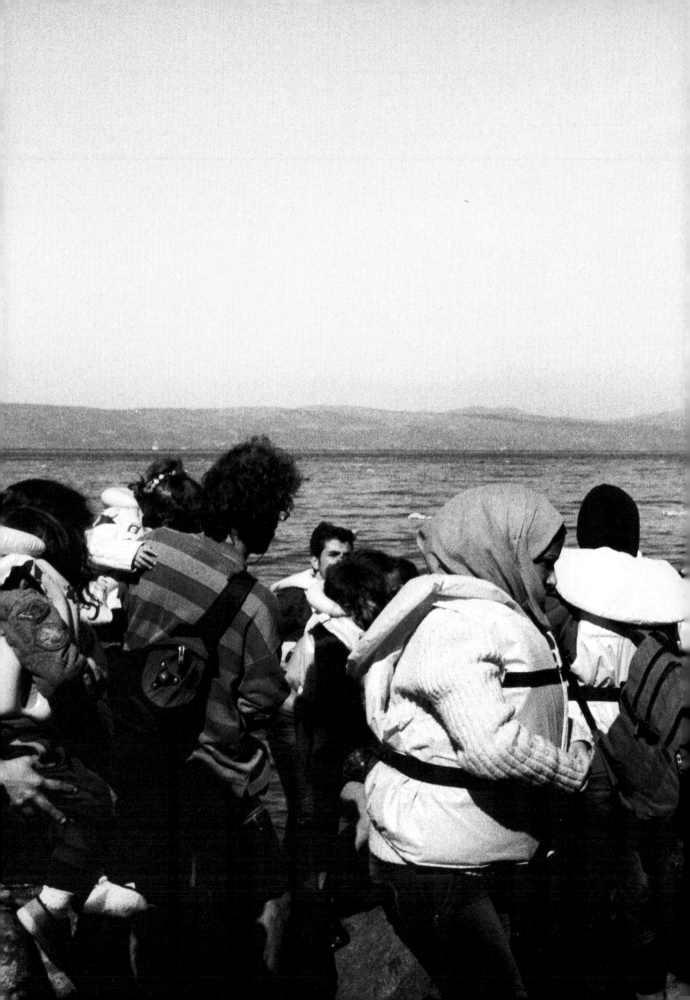

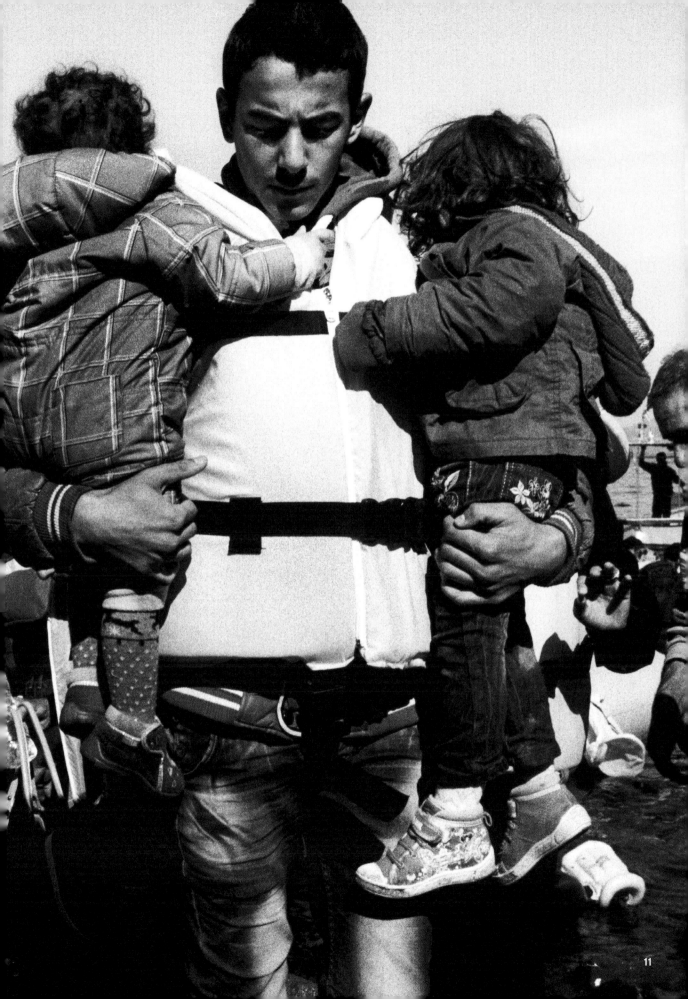

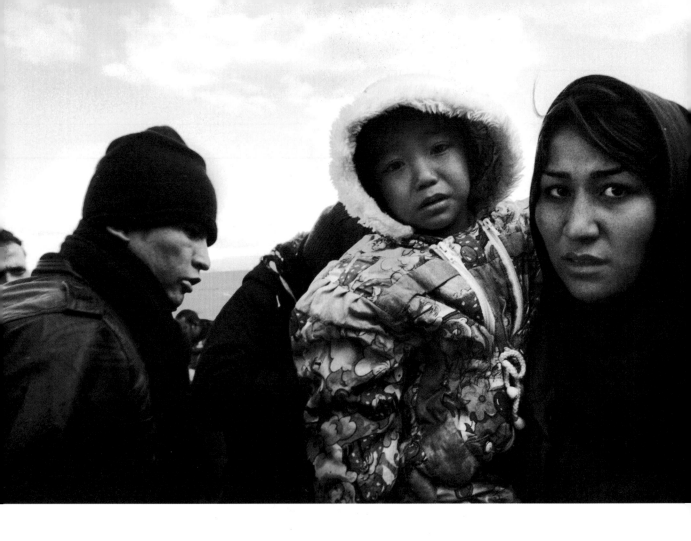

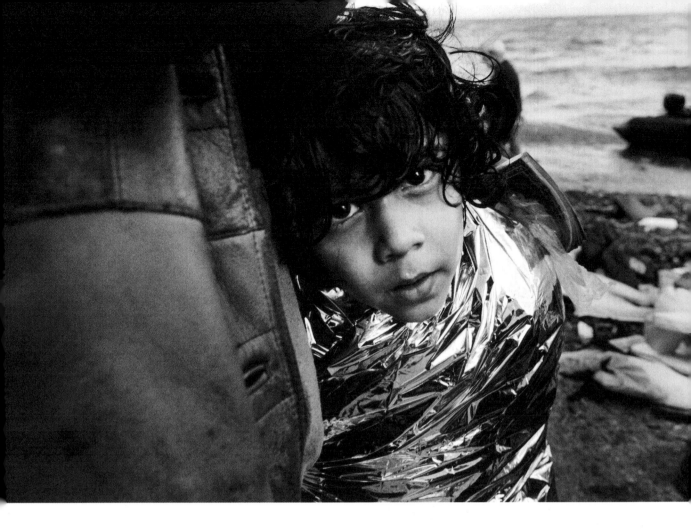

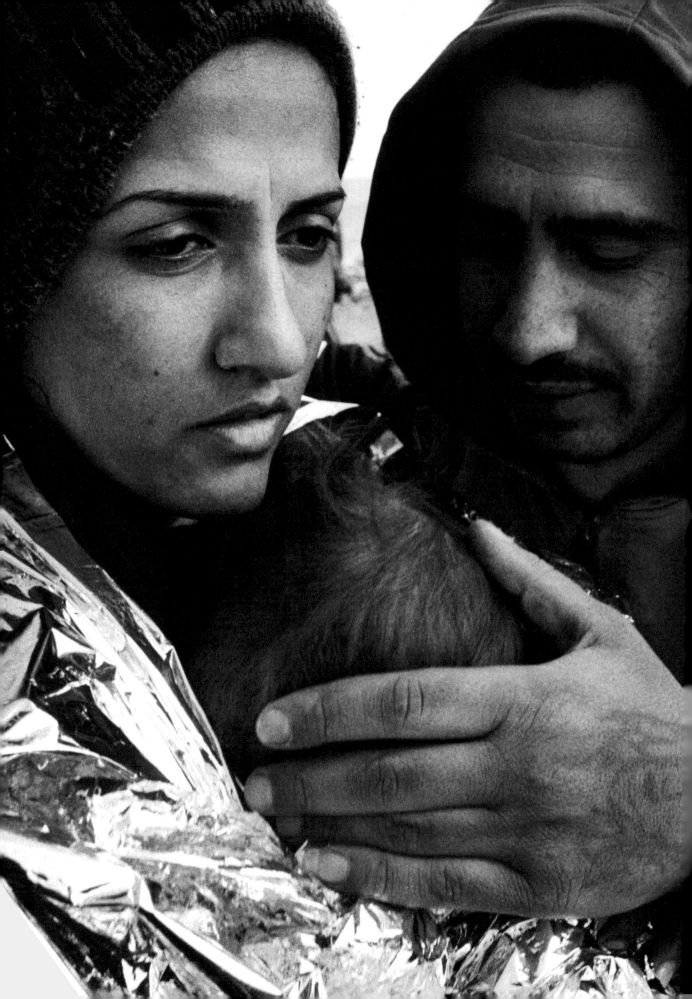

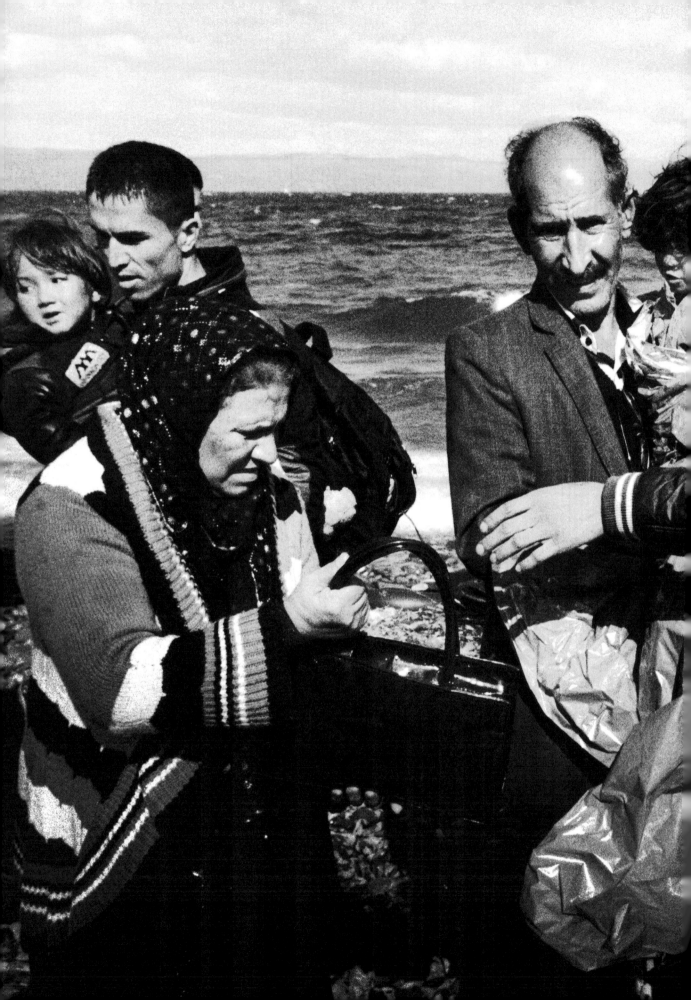

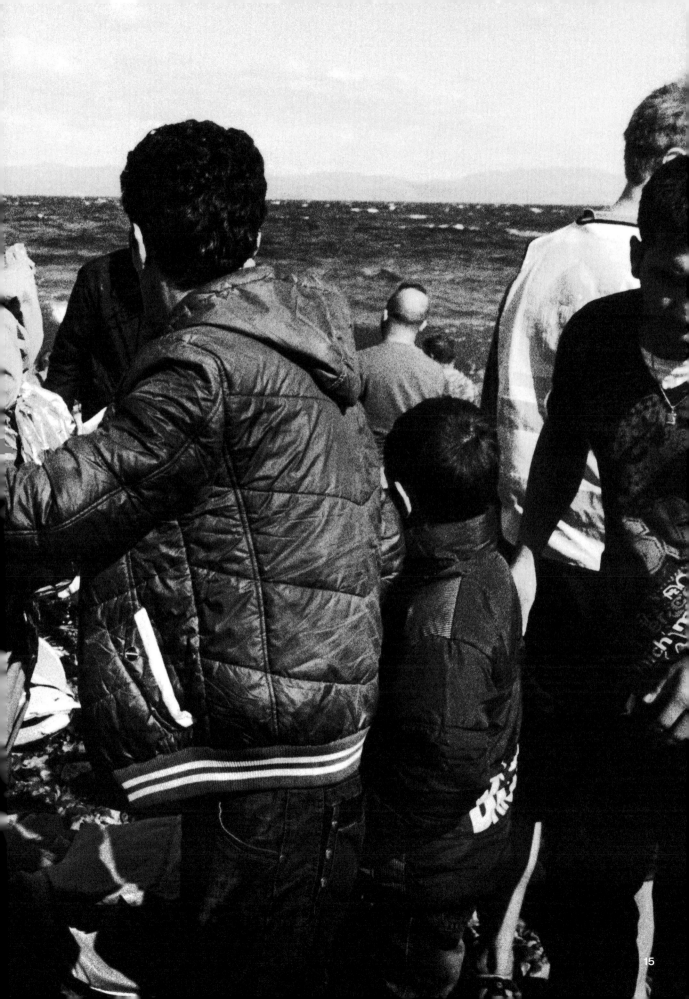

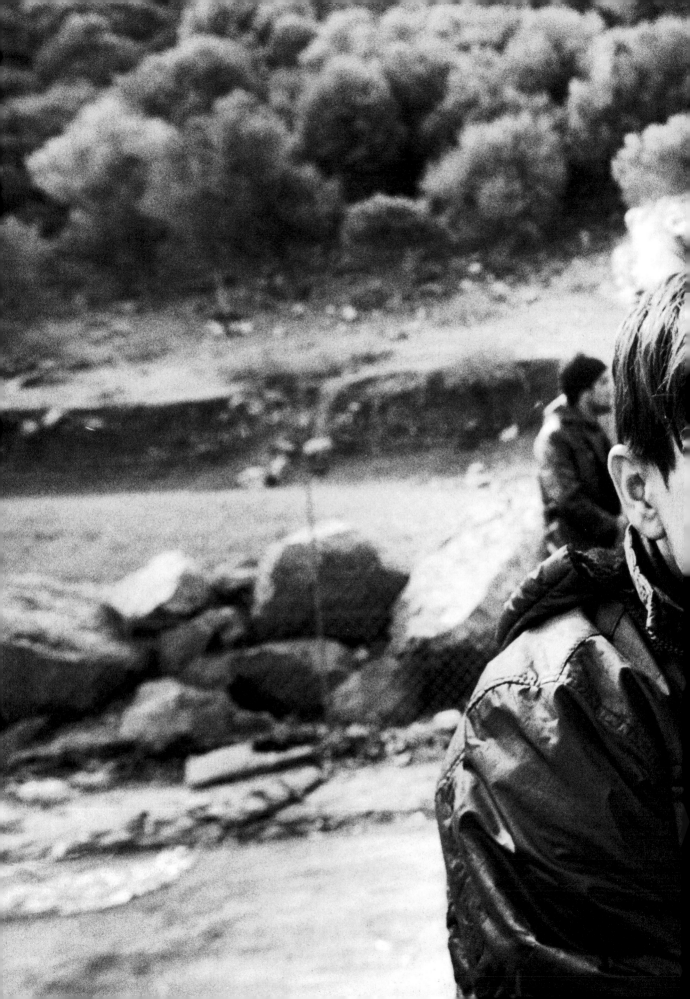

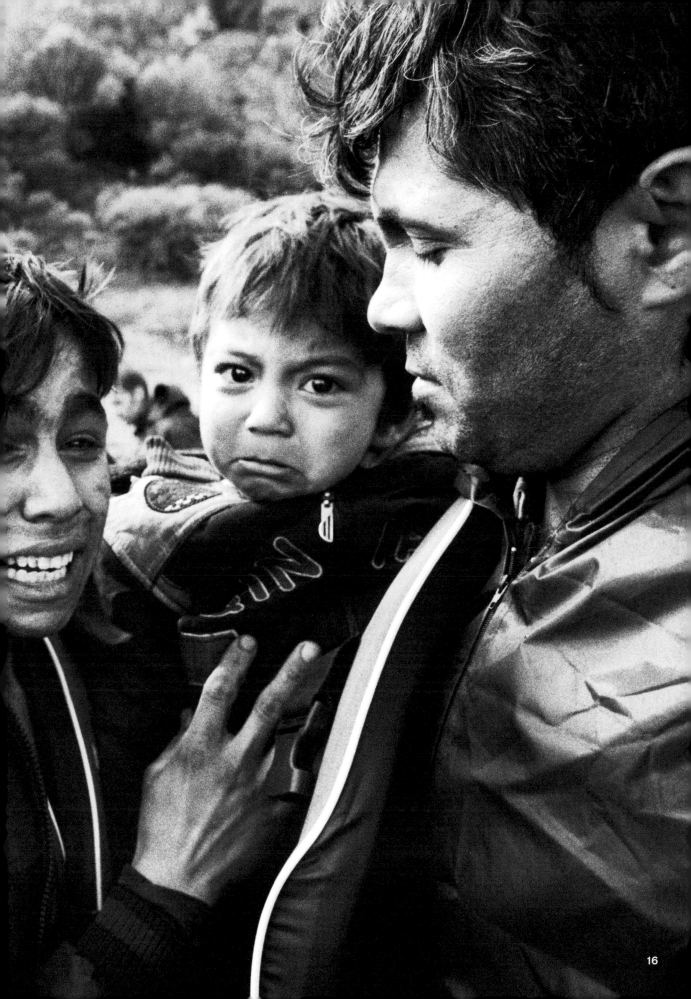

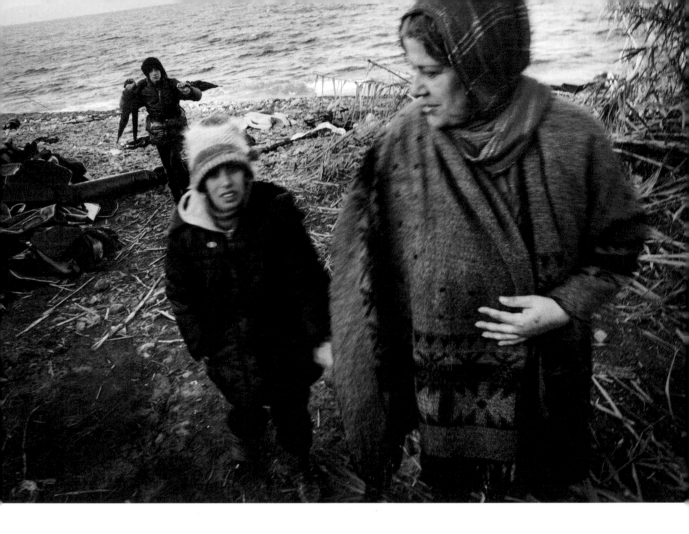

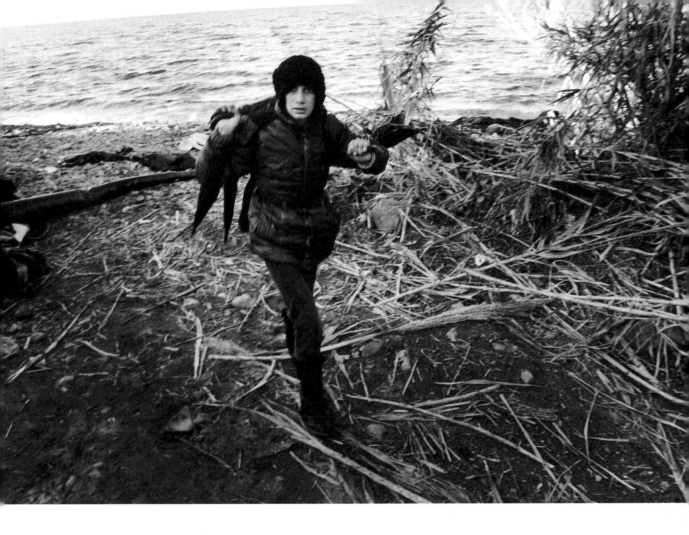

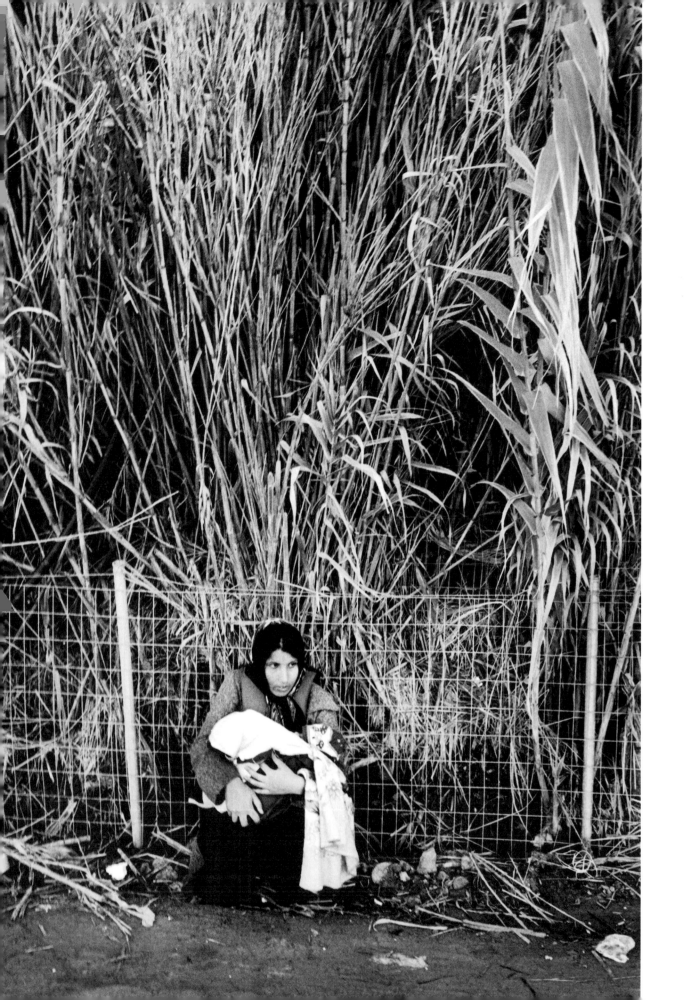

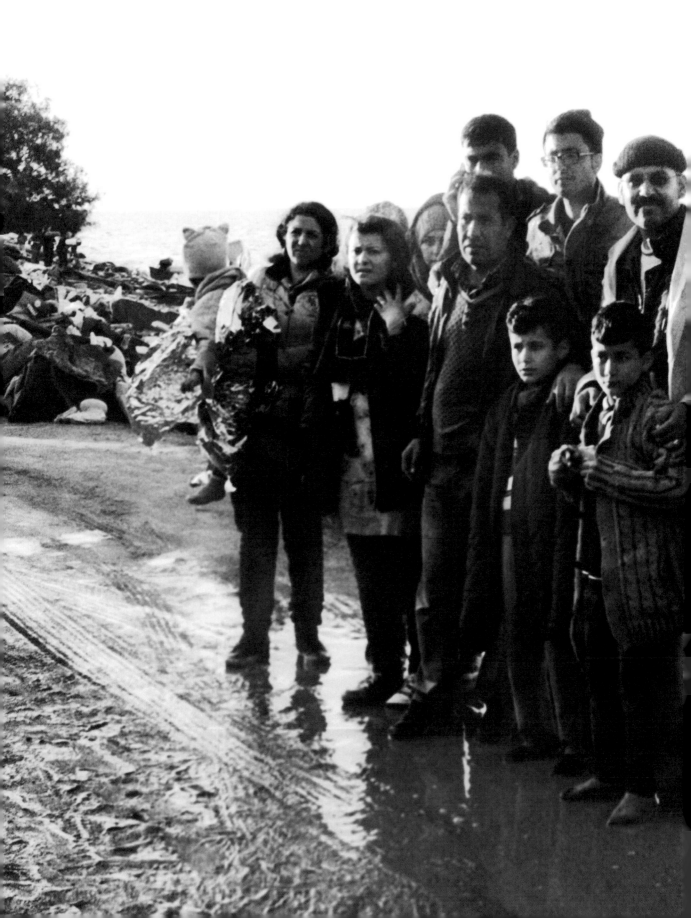

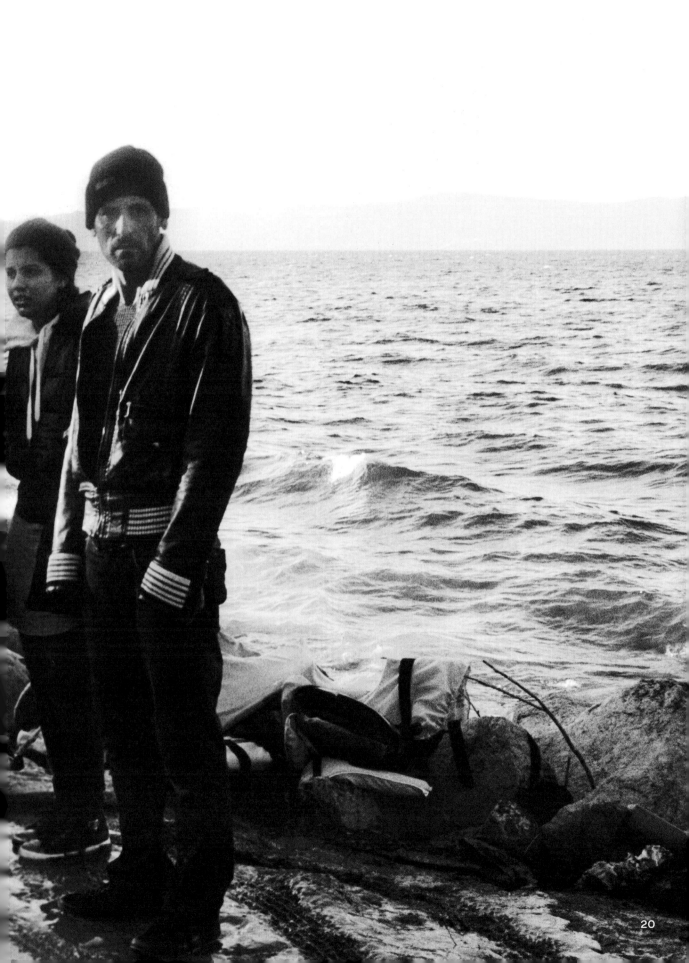

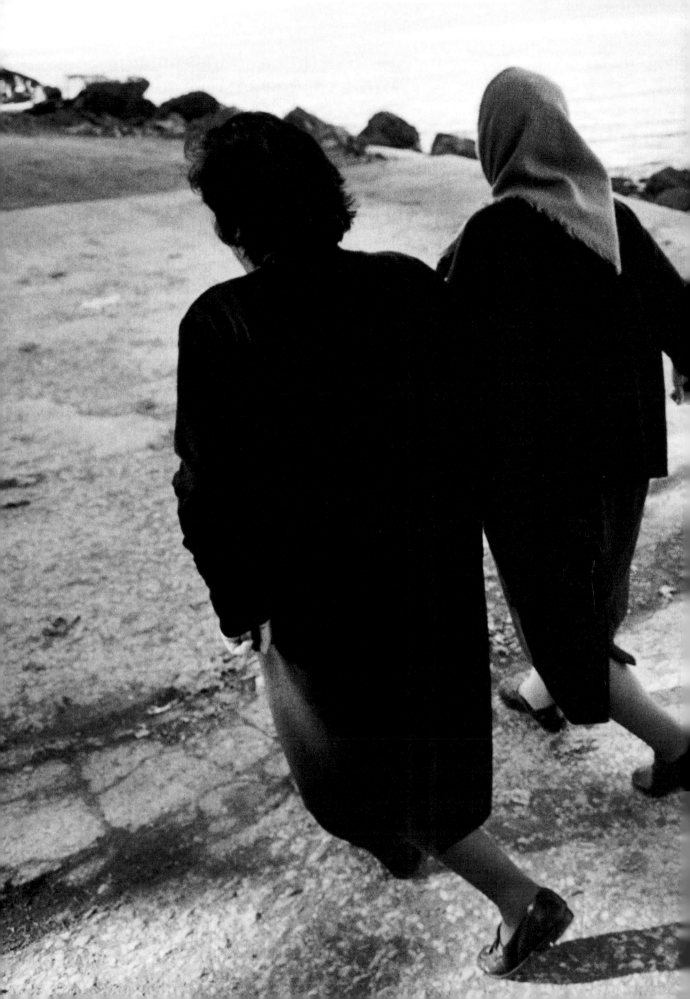

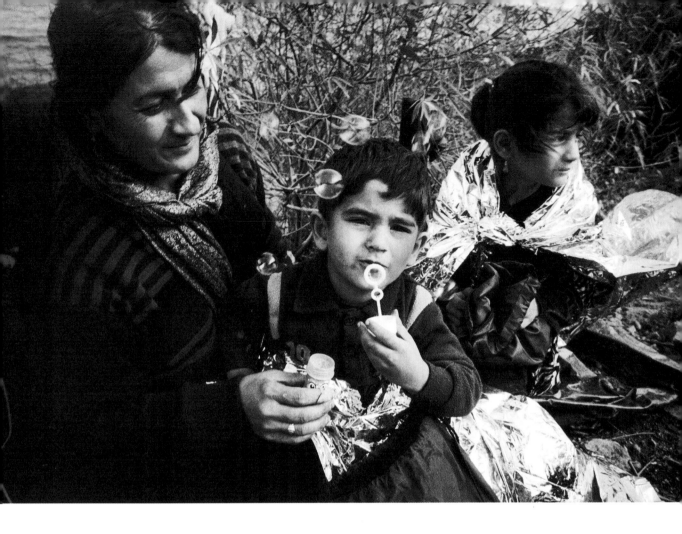

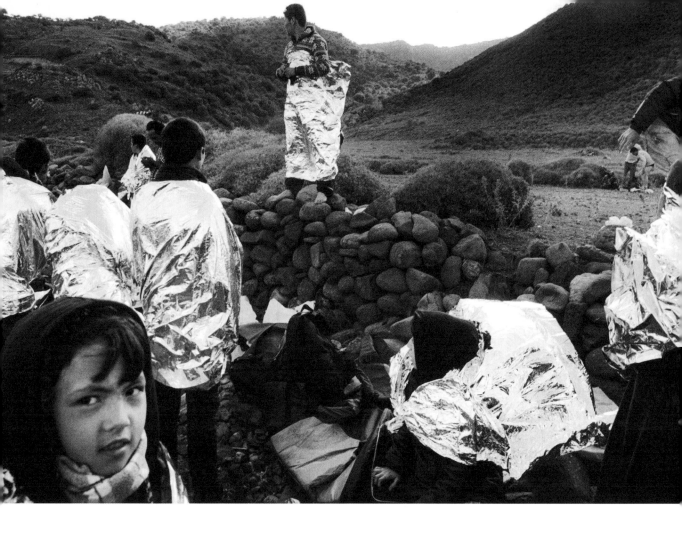

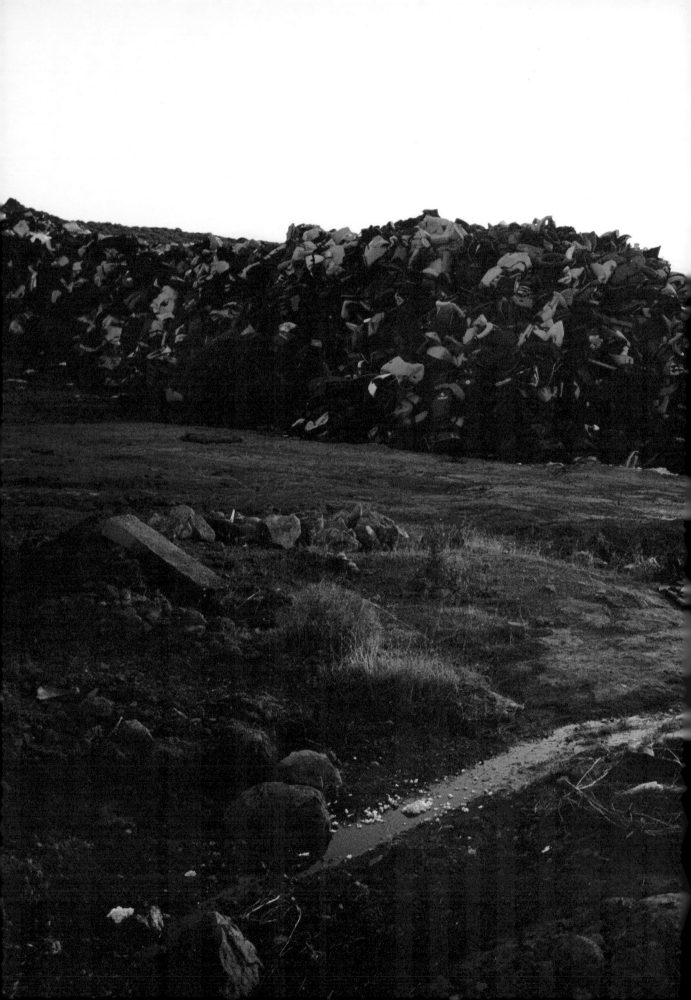

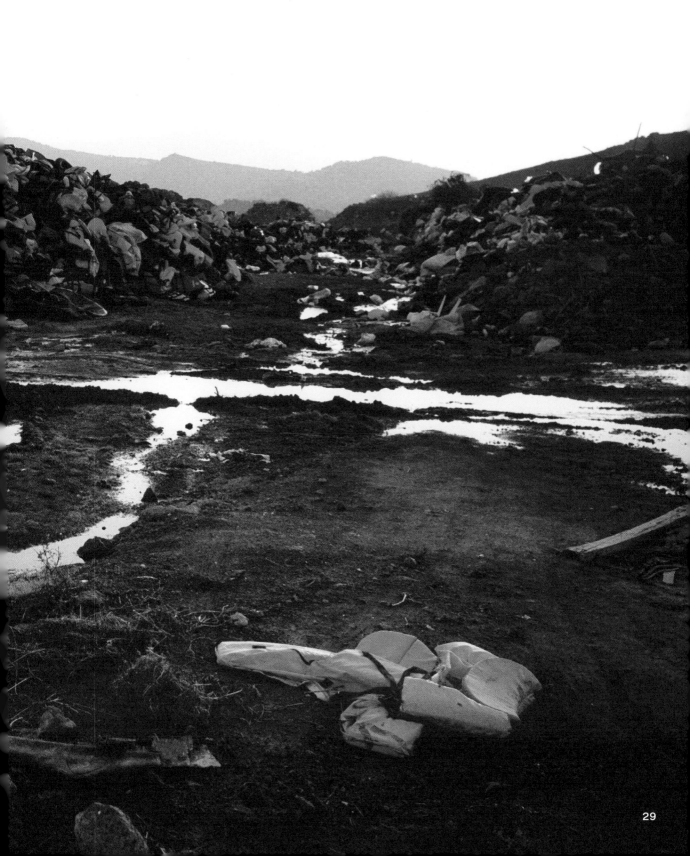

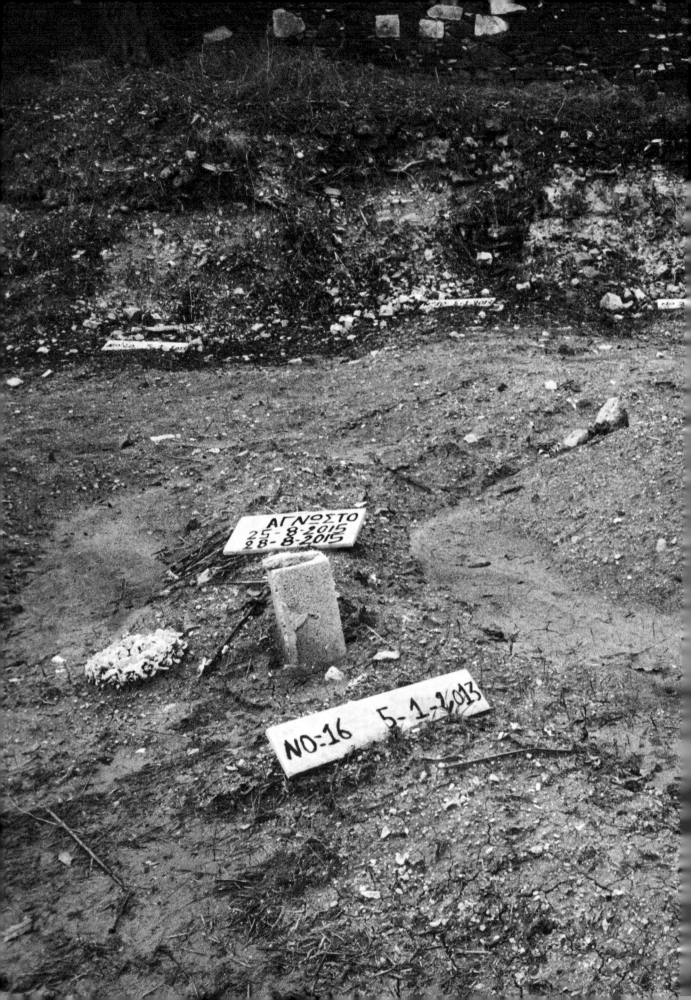

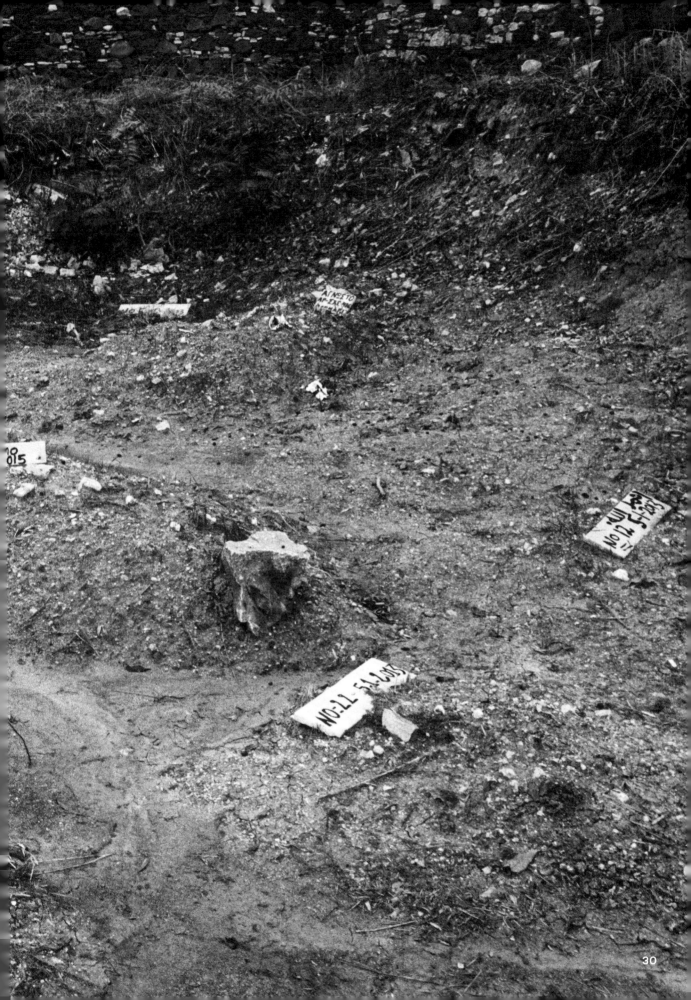

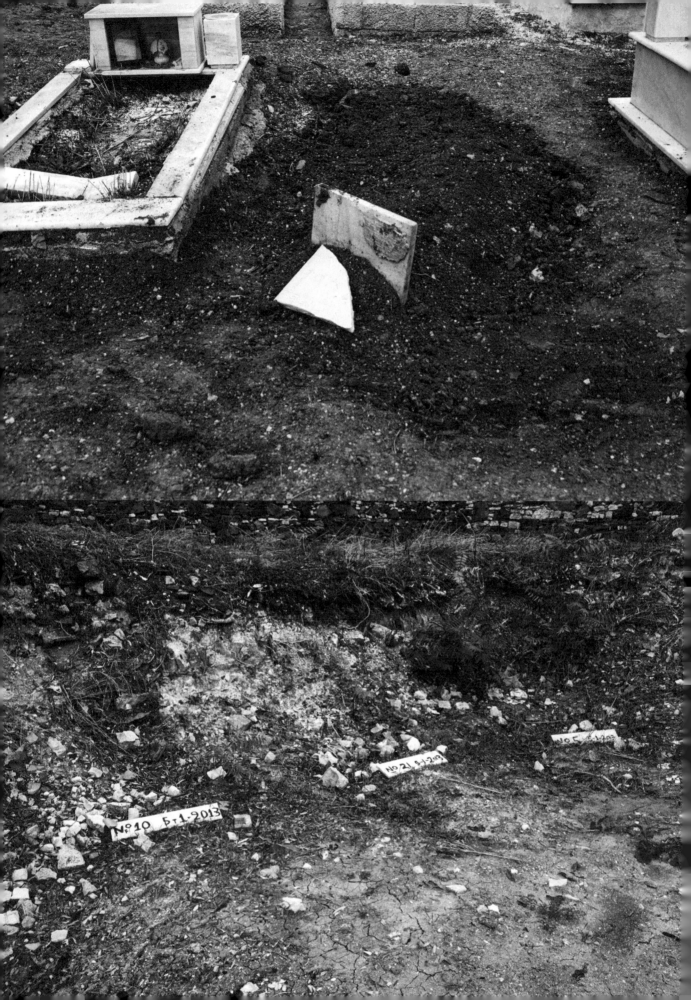

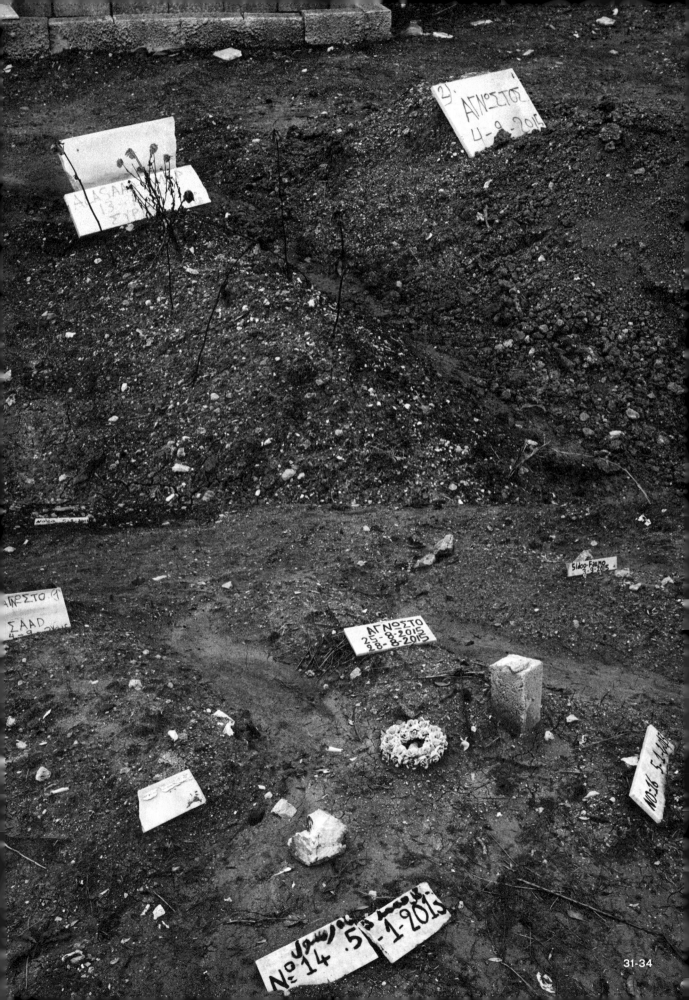

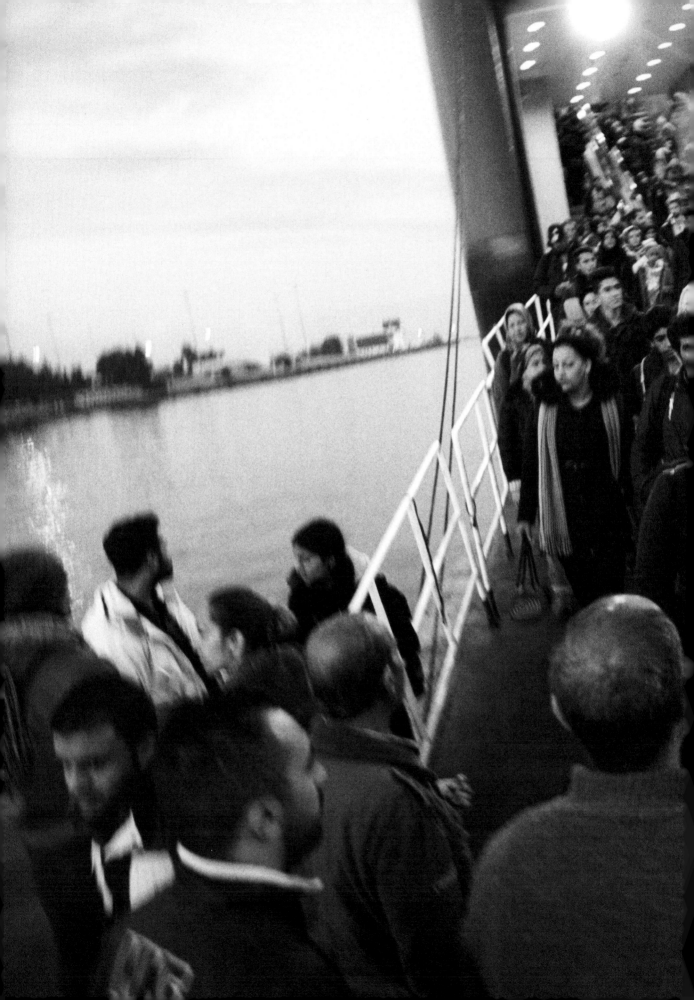

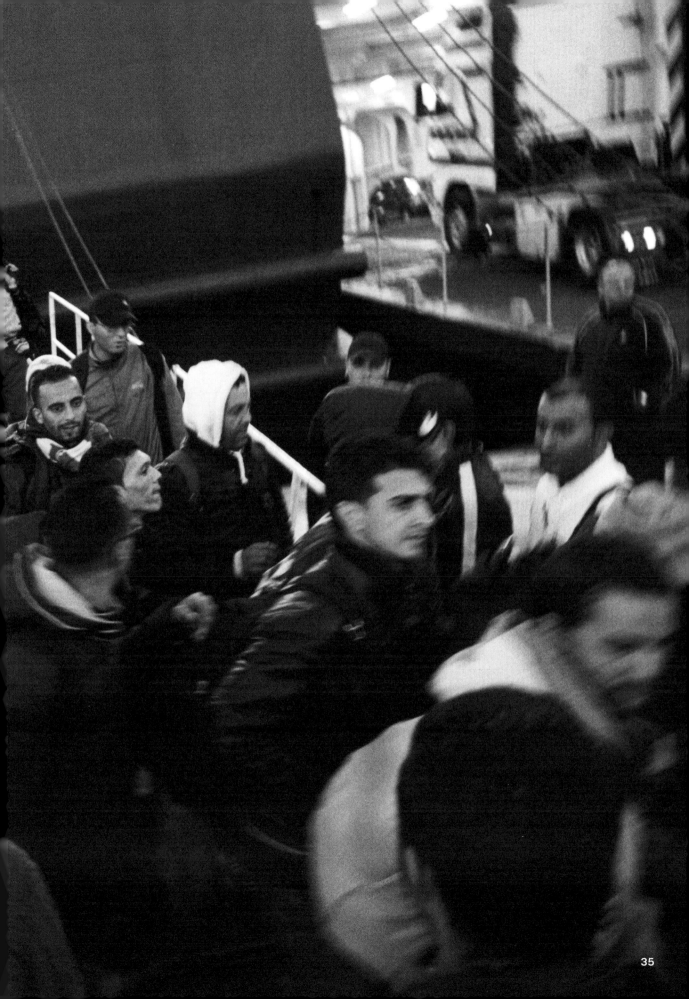

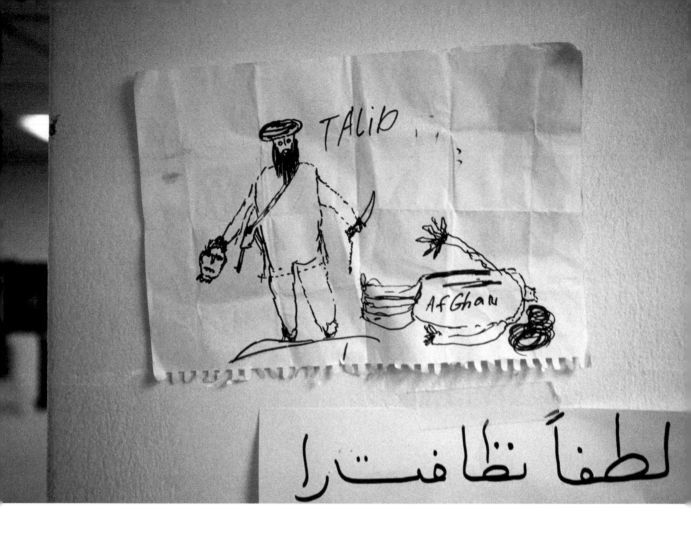

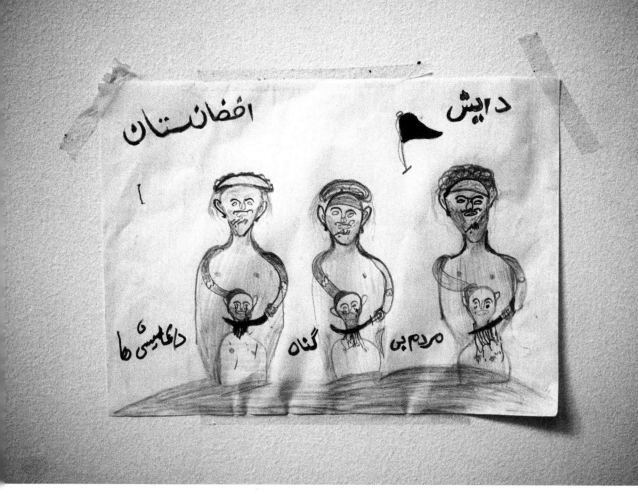

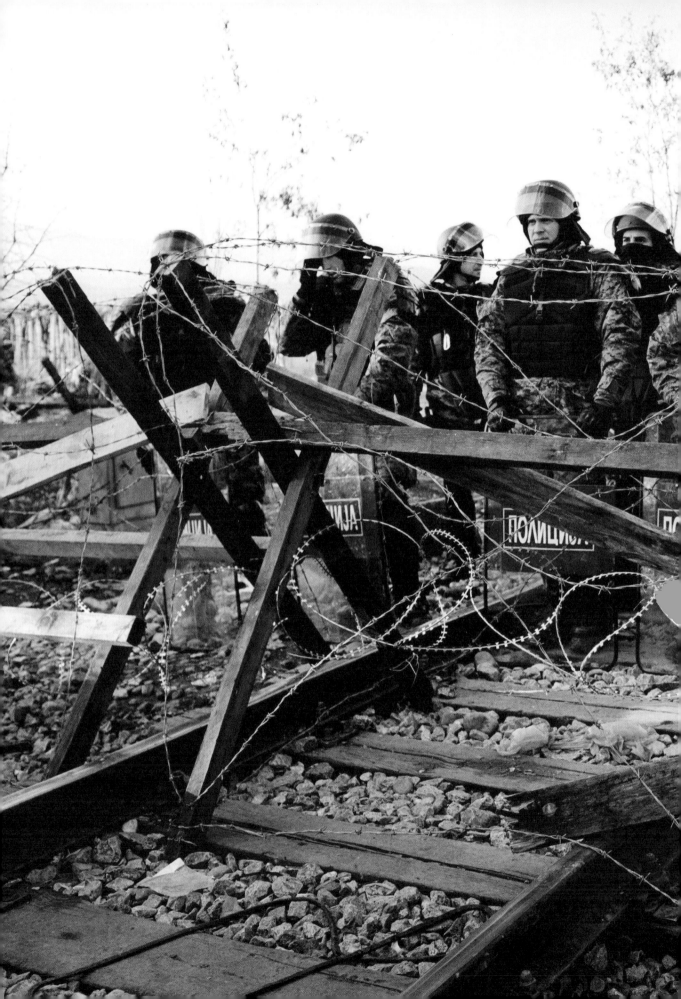

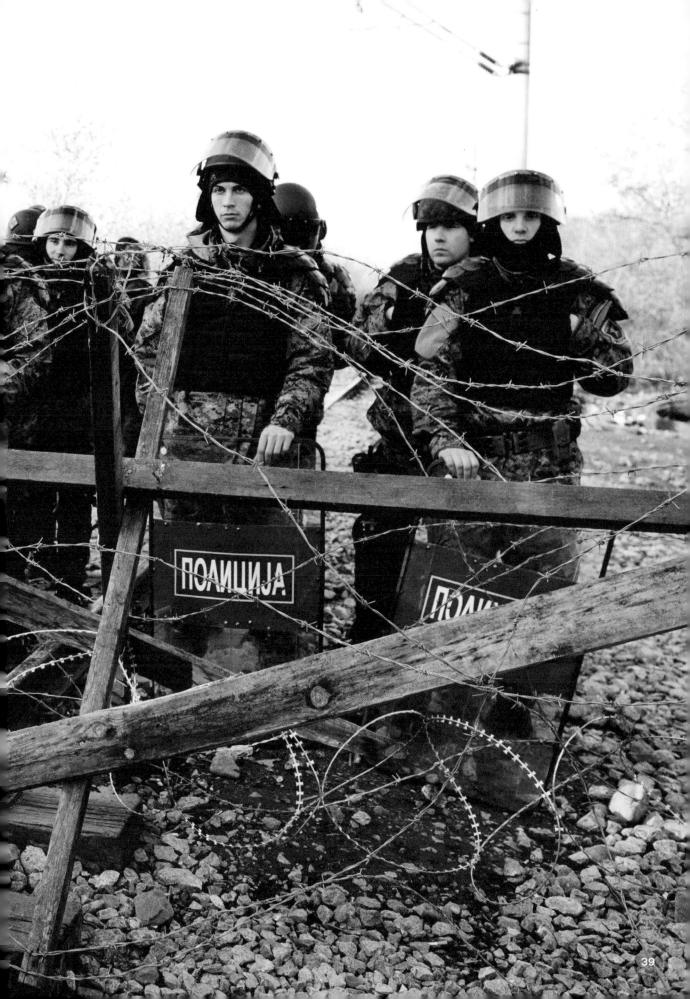

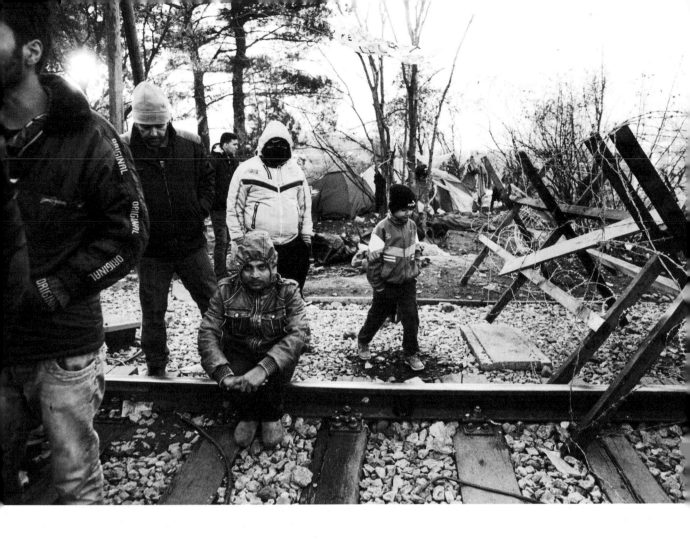

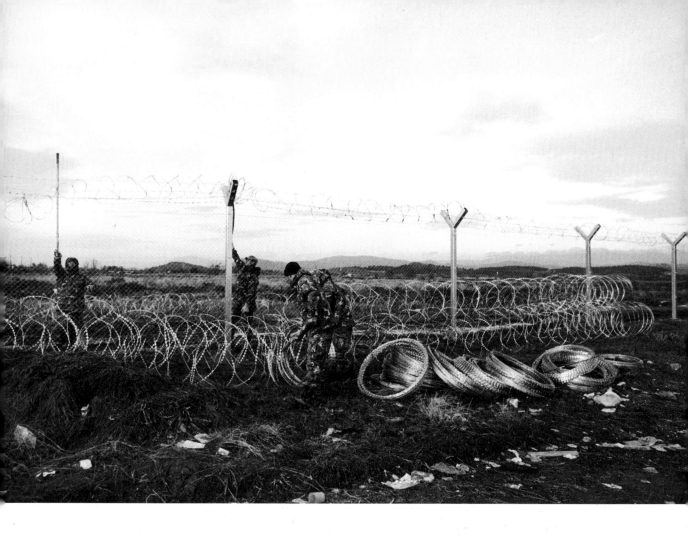

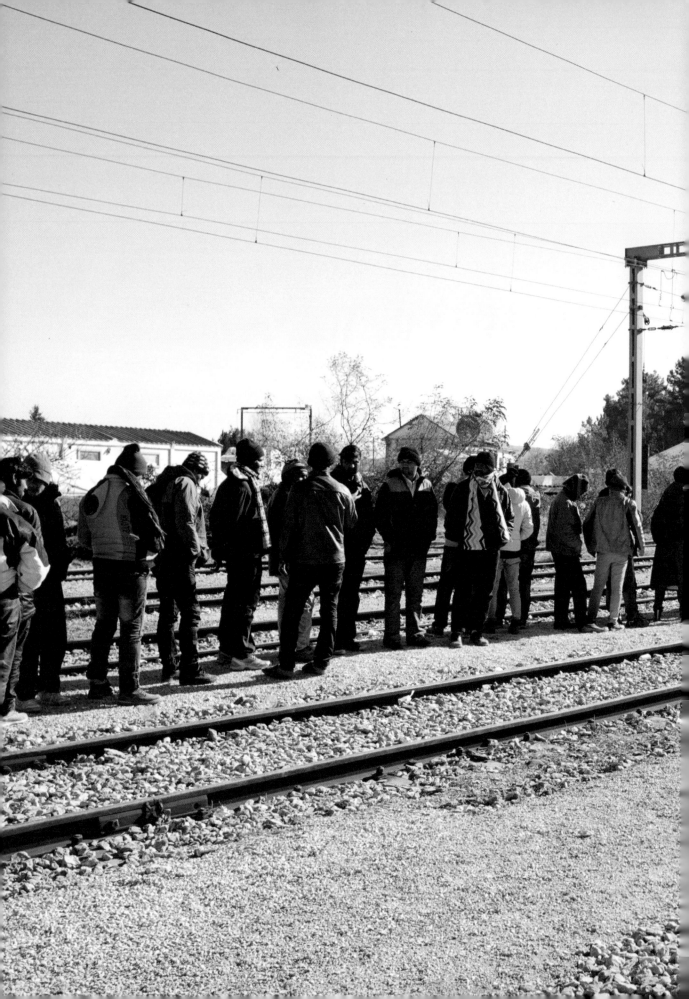

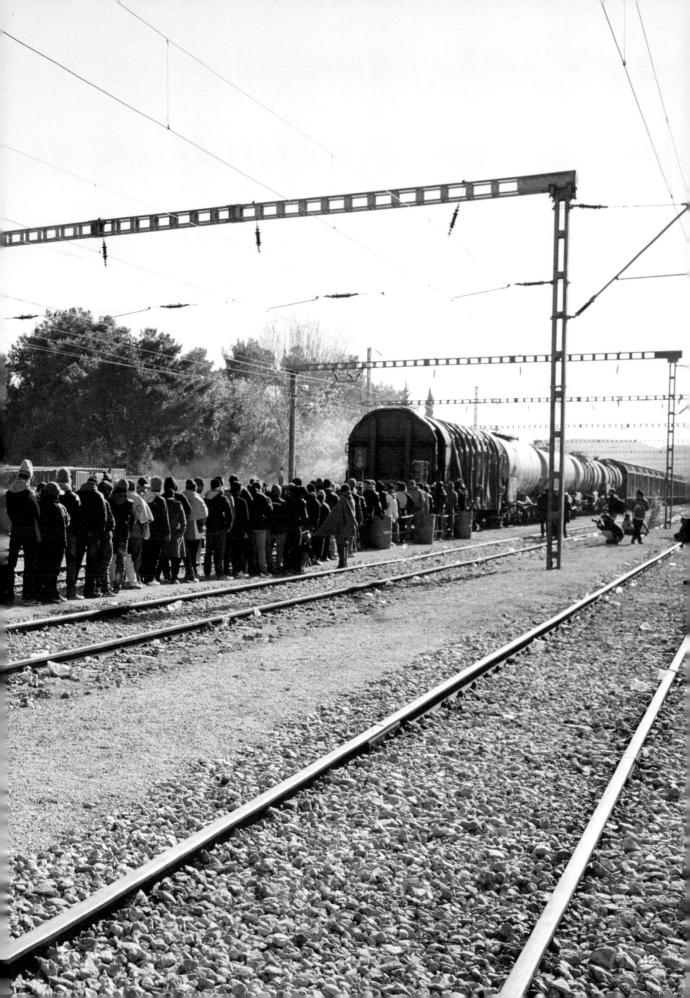

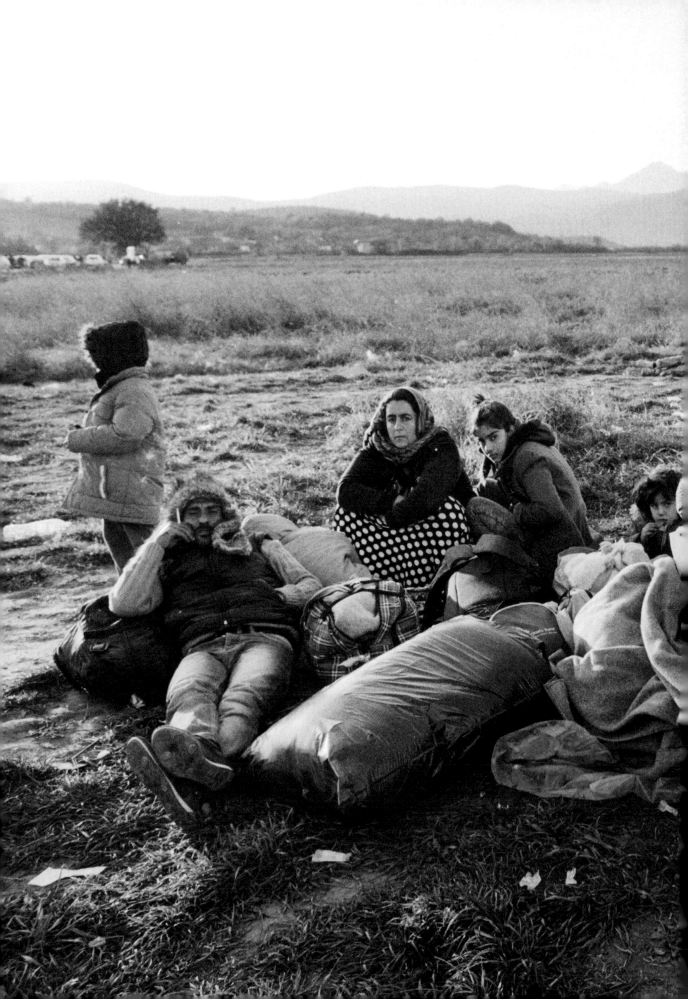

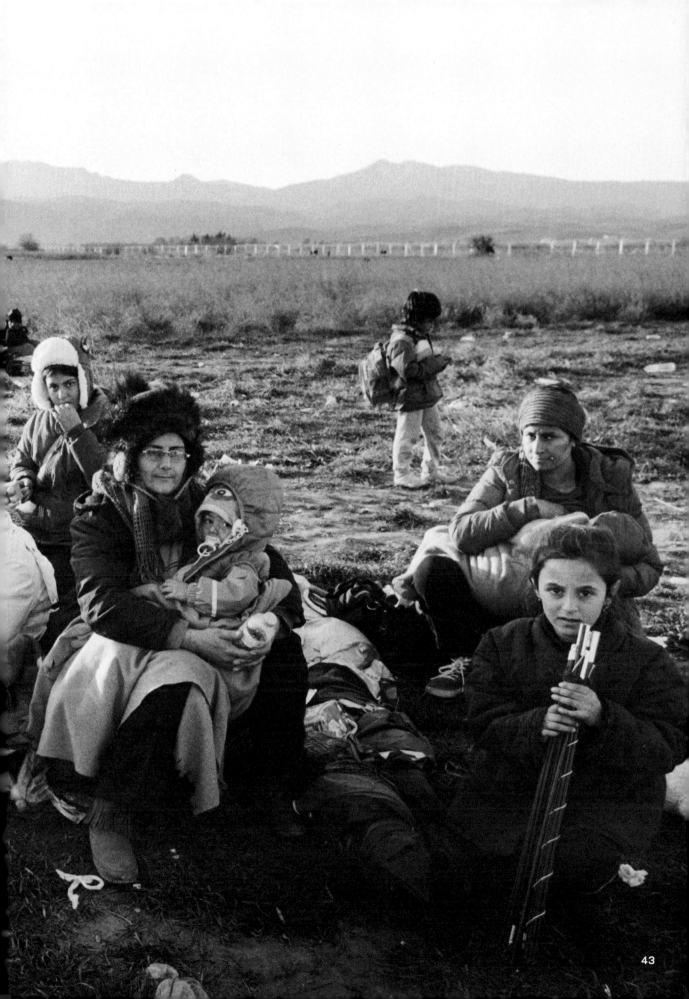

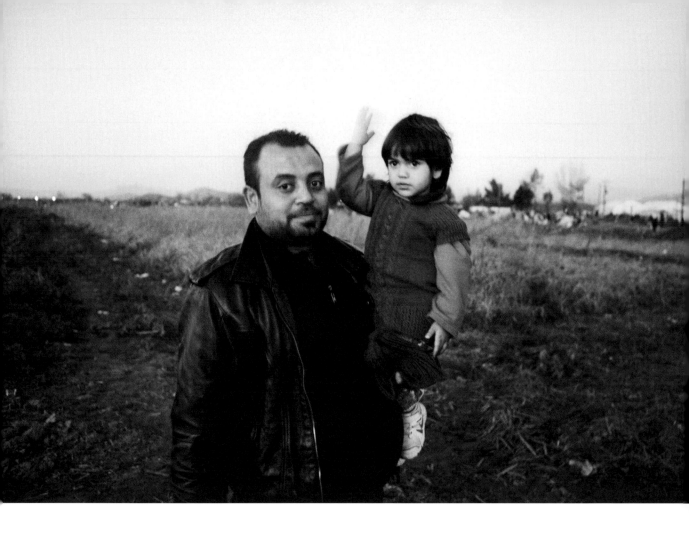

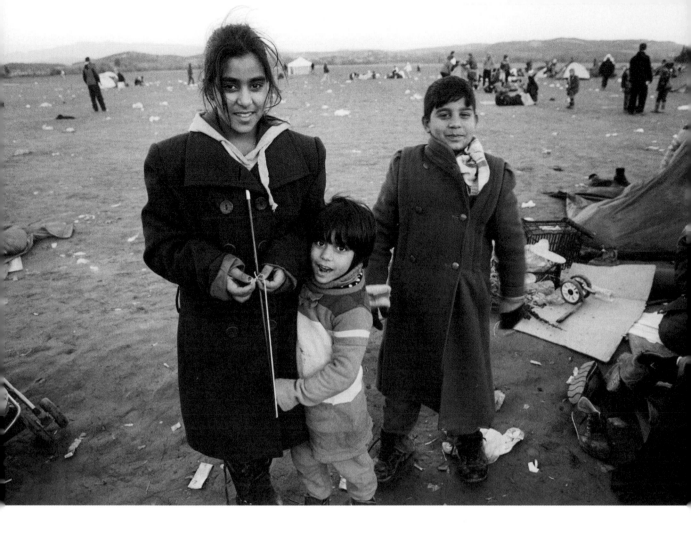

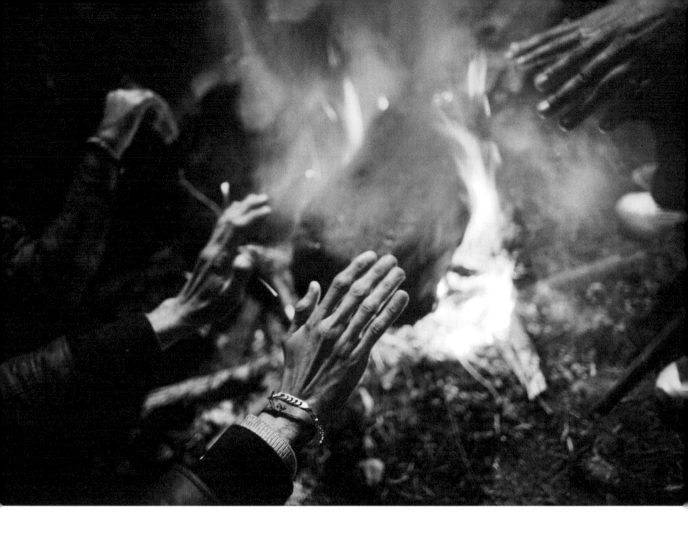

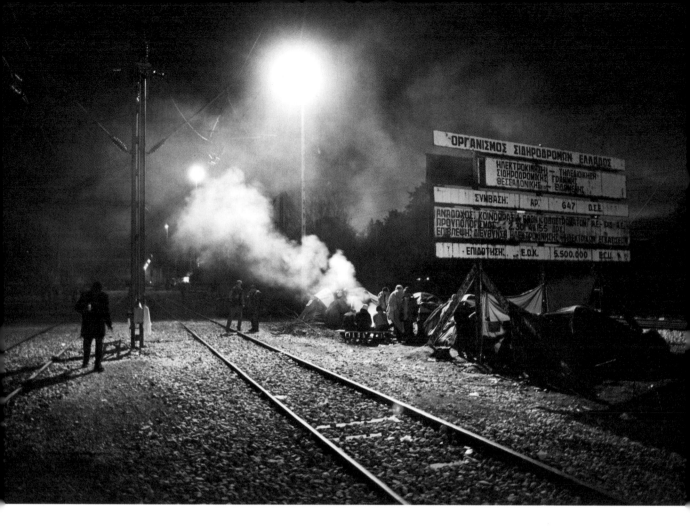

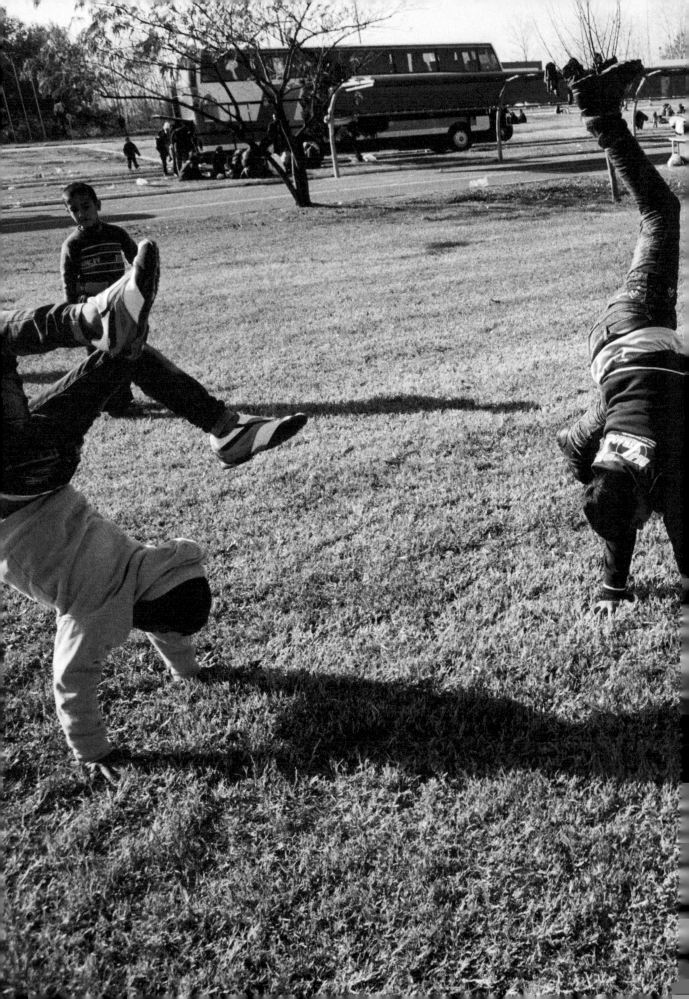

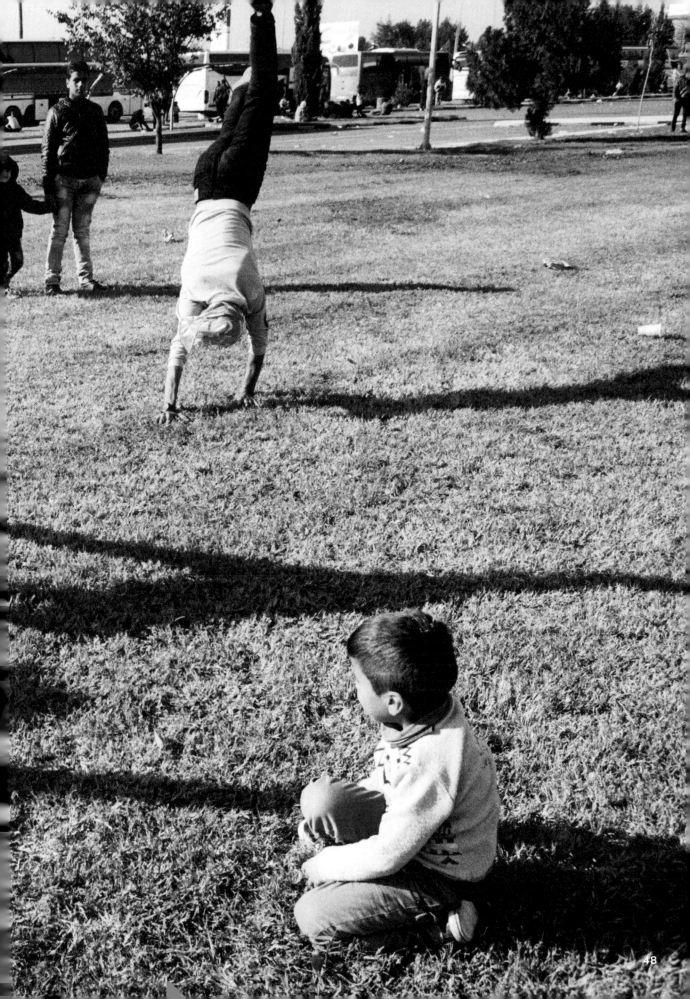

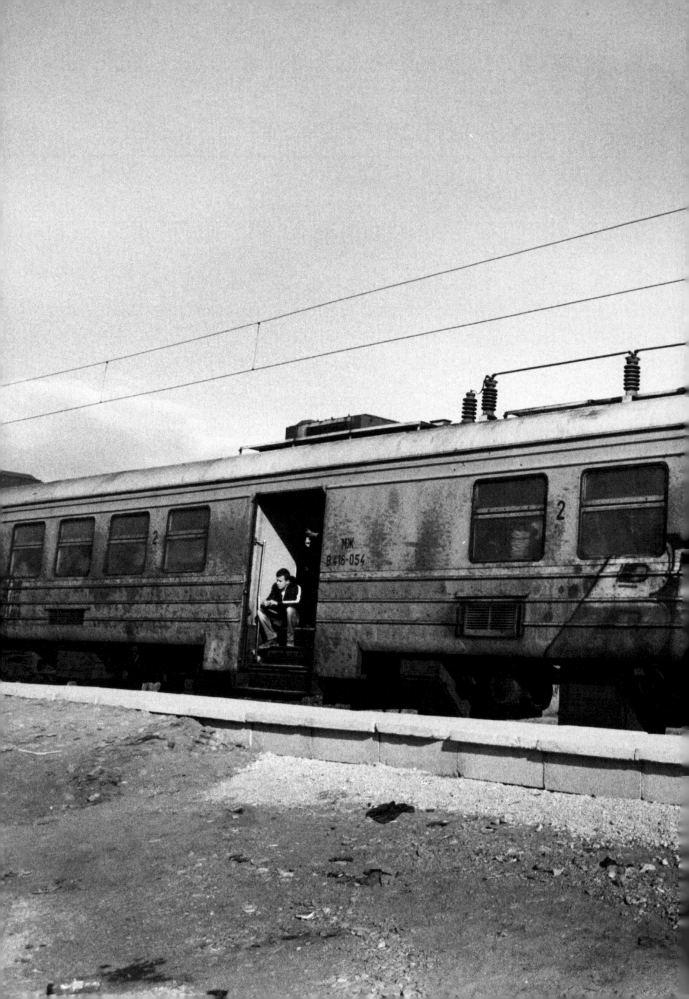

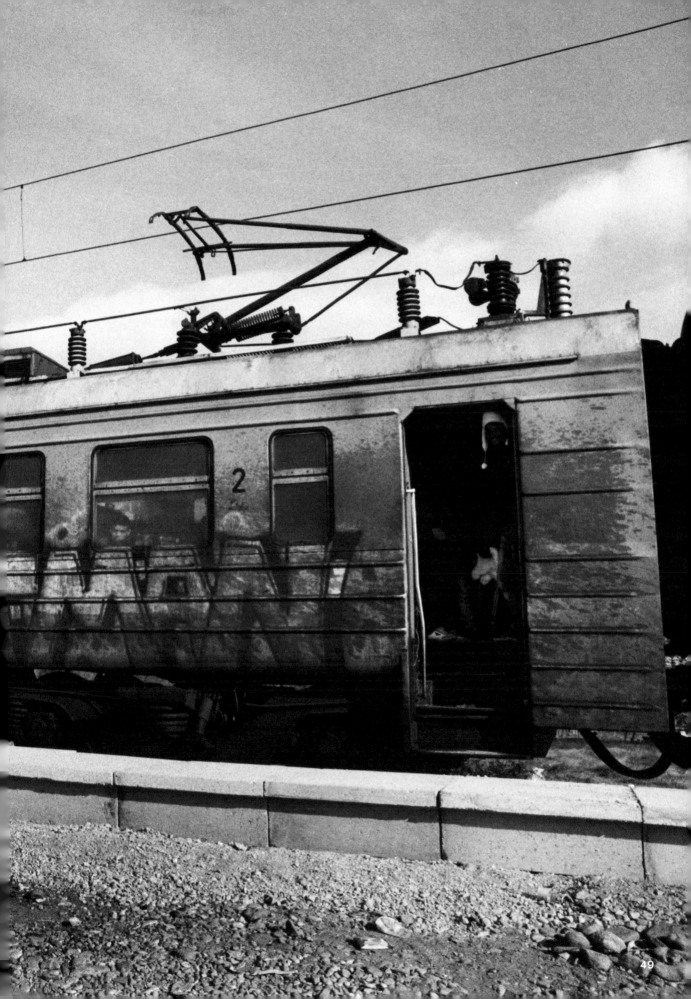

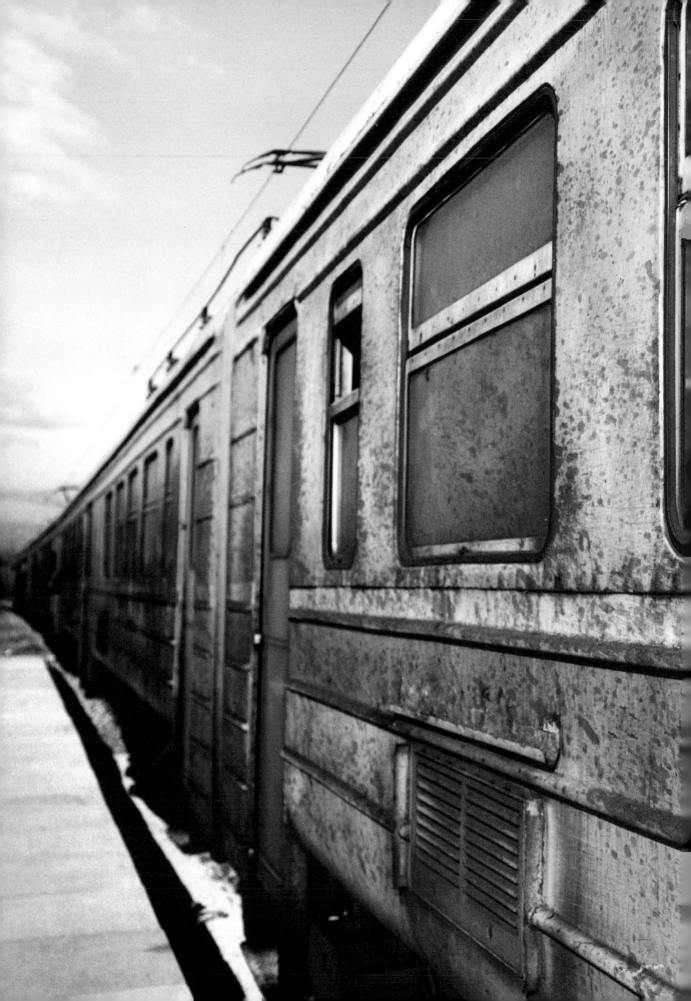

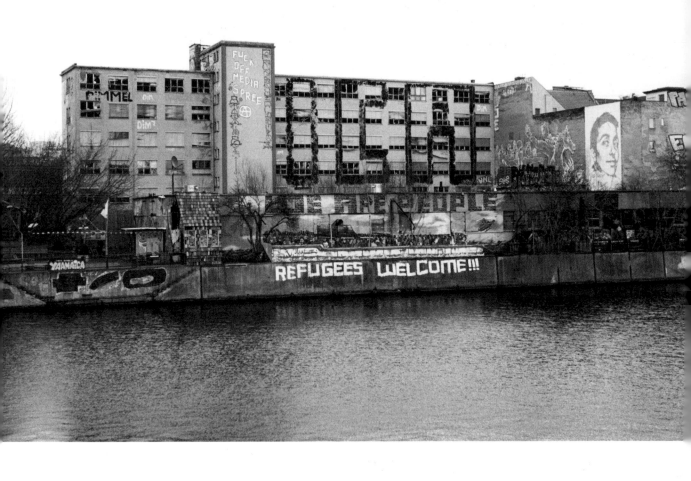

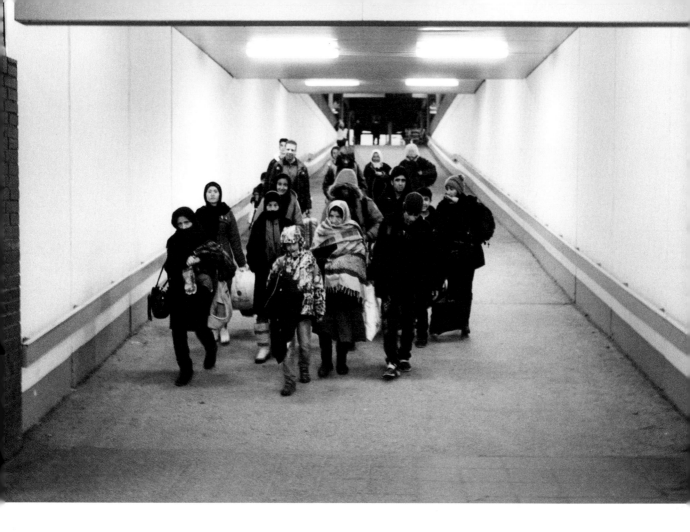

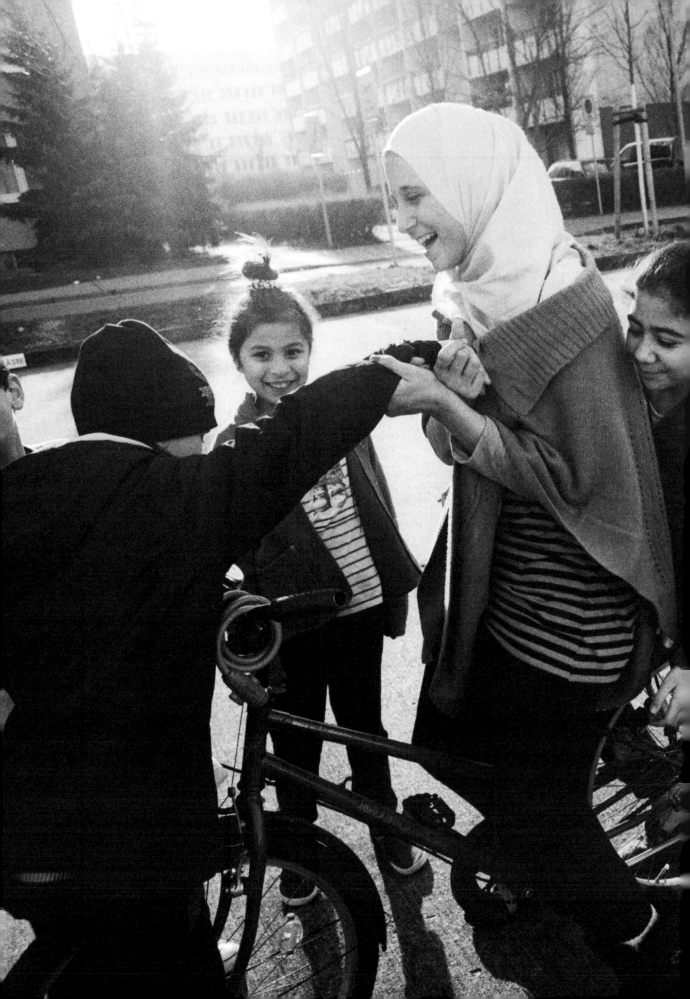

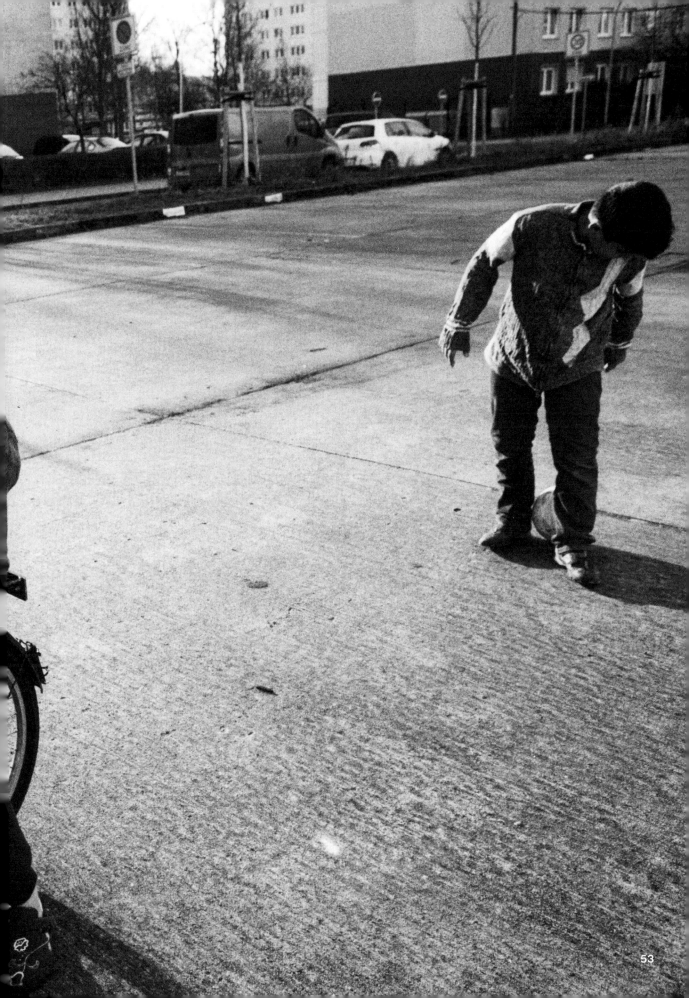

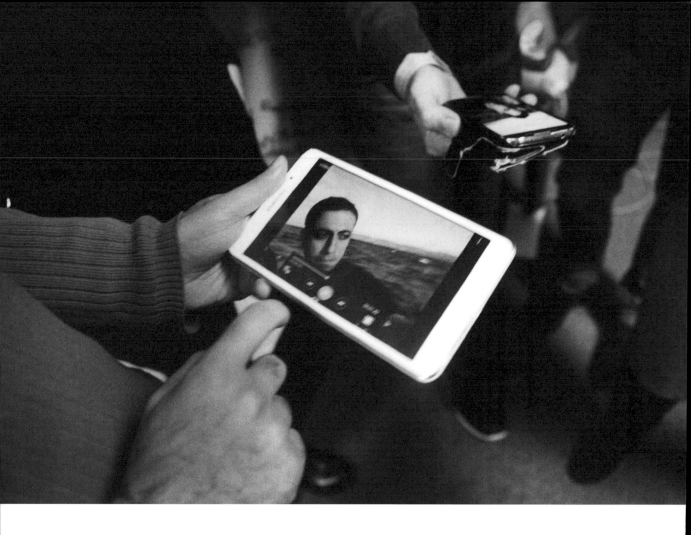

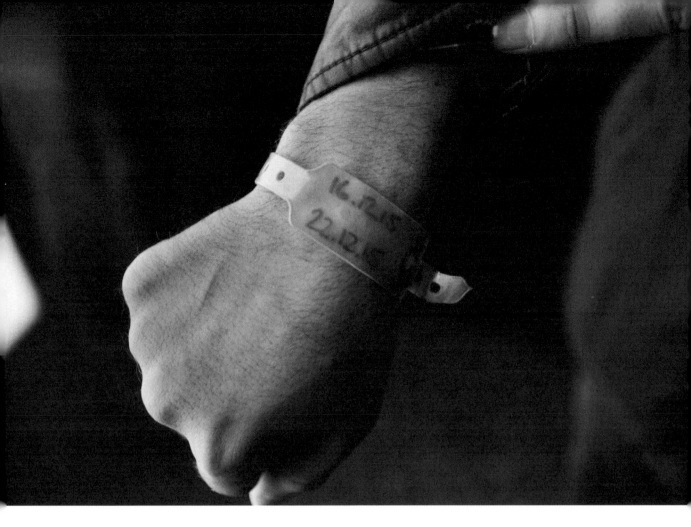

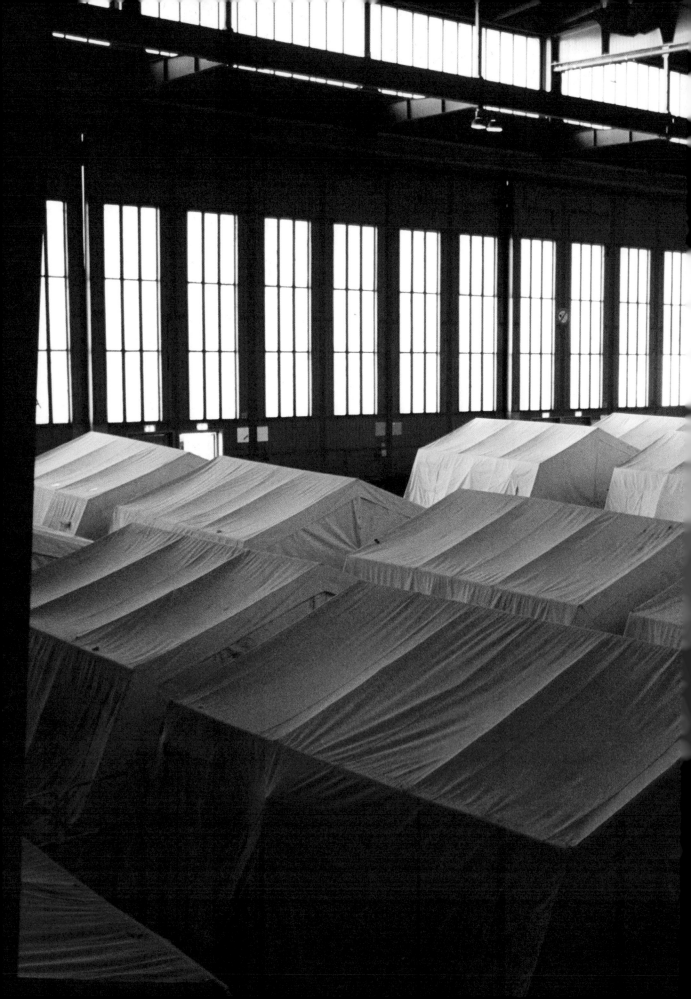

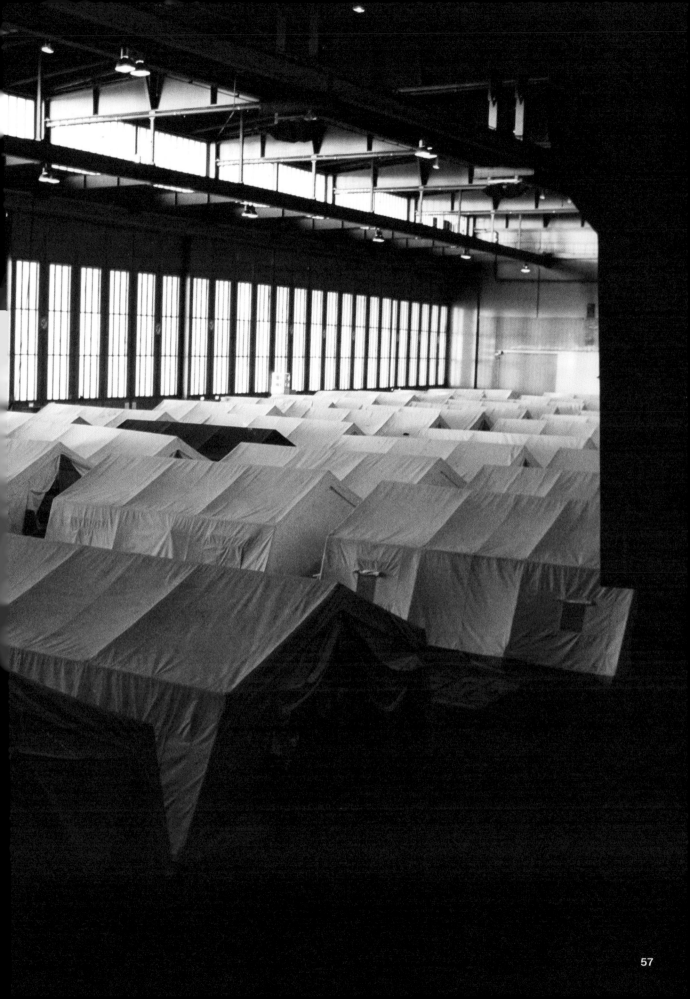

Giles Duley

Lesvos: A Cemetery of Souls

In mid-October, I arrived in Skala Sikamineas on the north coast of the Greek island of Lesvos. I was here as part of a long-term project for the UNHCR, documenting the refugee crisis across Europe and the Middle East. The events that have unfolded in the past few years are unprecedented in their scale, and scope. Not since the Second World War have there been so many peopleon the move. The UNHCR estimates that there are over 60 million refugees worldwide, with over four million Syrians alone leaving their war-torn country to seek safety in neighbouring countries and in Europe.

In my work as a photographer, for over a decade, I have documented the effects of conflict and humanitarian disaster across the world; much of that work has been in the countries from which these people are now fleeing. More than most, I understand the fear that is driving people to leave their homes. I thought I had seen it all, but I can honestly say I have never been so overwhelmed as by the human drama unfolding on the beaches of Lesvos. Its sheer scale is hard to comprehend; the lack of response impossible to explain or excuse.

In scenes more reminiscent of the Second World War, I have watched thousands land on these shores, fleeing wars in Afghanistan, Syria and Iraq. Again and again they say to me, 'we thought we would die on that boat, but at least there was some chance, what we left behind was certain death.' No person should be forced to risk death in the search for safety.

On landing, men break down into tears, women stand lost in visible shock, children cry hysterically. The noise and chaos is deafening. Humanity is laid bare on the shores of Europe, and the response from politicians is a shambles. It is volunteers who hold this frontline: a nurse from Palestine, a doctor from Israel, volunteers from Oslo and Bolton, lifeguards from Barcelona, and the fishermen who call this stretch of coast home.

When survivors, on landing, shake your hand and say 'thank you', I turn ashamed, for they have nothing to thank us for here. If this were ever to be my family seeking safety, I would hope the world would treat them better. We can get into long arguments about the root causes and possible solutions; we can discuss the difference between refugees, asylum seekers and migrants; we can blame traffickers and smugglers. The simple truth right now though is that men, women and children are suffering terribly and dying on the coasts of Europe. For the sake of humanity alone we must help them, not turn our backs.

My first films from Lesvos have been developed and to be honest, it's too heart-breaking to even start looking through the contact sheets. In the calm of a café, I can see the fear etched on the faces of those I've photographed. As I sit there the village Mayor joins me. The local population is struggling with the impact of this crisis too; he's trying to hold together a community battered by tragedy. 'How can anything be normal when each day you see a drowned child? This coast,' he says, dropping his head, 'has become a cemetery of souls.'

It's nearly 11pm here in Lesvos. Today, 3rd November, has been one of the busiest on record for refugees arriving, and the boats are still coming. Estimates put the figure arriving on the island at over 7000. Two men and two children drowned. The camps are full, the volunteers and agencies overwhelmed. Families are sleeping wherever they can. An Afghani father with a baby in his arms asks for somewhere to sleep; he offers to pay three times the price in a hotel, even just for his wife and baby. When it's explained that there is nowhere left and no blankets, he asks "Touch me. Am I not human too?"

This is Europe, this is today.

November 2015
(Originally published in The Observer)

Lesvos, Greece

1. A boat carrying over 40 Afghans approaches Lesvos after crossing the Aegean from Turkey. (31 October 2015)

2. An inflatable boat with nearly 40 Syrian refugees on board drifts helplessly towards the cliffs after its engine stalled. From where we stood, we could hear the screams as the boat took on water from the waves that crashed against it. (29 October 2015)

3. Volunteers, using a salvaged smugglers boat, rescued the boat after its engine failed. (29 October 2015)

4. Survivors struggle ashore after their boat ran into trouble. (28 October 2015)

5. An overcrowded boat of refugees heads to the shore. Two men had fallen from the boat; they were rescued by volunteer Spanish lifeguards. (28 October 2015)

6. Thanasis, a local fisherman, rescues a boat that had become stranded. He has brought boats in everyday since June. For the fishermen the crisis has been particularly hard, as Thanasis explained 'how can we go fishing if each day we see dead bodies? You lay your nets, but have to abandon them to rescue a boat. Of course their lives come first'. (3 November 2015)

7. On landing a woman collapses, the boat she was on had been drifting at sea for hours. (29 October 2015)

8–9. The Greek Red Cross treats an Afghan refugee who is suffering from hypothermia. The boat had partially sunk, leaving the survivors in the water for nearly six hours. (29 October 2015)

10. In the week of 22–28 October; there were on average 5,800 arrivals a day on Lesvos, of these 52 per cent were Syrian and 19 per cent from Afghanistan. (26 October 2015)

11. A father carries his two children from the boat after landing. (26 October 2015)

12. An Afghan mother holds her child moments after landing on the beach near Skala Sikaminias. UNHCR and its partners work to prevent family separations and create safe areas for women and children who are particularly vulnerable. (26 October 2015)

13. A boy from Afghanistan tries to keep warm after a cold and wet crossing from Turkey. Cases of hypothermia are on the increase as the weather deteriorates across the eastern Mediterranean. (28 October 2015)

14. A family gathers itself after reaching shore. Most are between shock and relief. (28 October 2015)

15. A family of several generations disembark from an overcrowded boat. Almost 40 per cent of refugees currently arriving on Lesvos are from Afghanistan. (28 October 2015)

16. The words uttered again and again by those landing on the beaches of Lesvos are 'Shefna el mot bi oyouna' 'We saw death with our own eyes' (26 October 2015)

17–18. A well-dressed Syrian woman walks inland after landing on the beach. The second child carries their only belongings: three umbrellas. (26 October 2015)

19. Moments after their boat landed an Afghan woman, with her baby, sits in shock by the beach. (28 October 2015)

20. A family poses for a photograph on the beach, moments after landing. For me, their expressions tell me all I need to know of their journey. This is not a photo to celebrate, this is a photograph to say; we are at least alive. (28 October 2015)

21. Efstratia and Irini take a walk along the beach from Skala Sikaminias to visit a small transit camp, where each day they welcome refugees. Especially the children, who they hug and comfort. Skala Sikaminias is no stranger to refugees; in the 1920's many fled Turkey to Greece. Eighty percent of the village's inhabitants are direct decendants of refugees themselves, including the parents of Efstratia and Irini. 'When we see these children, we see our mothers' they explain. 'They were the same ages when they arrived here, with nothing.' (4 November 2015)

22. A young Afghan boy is looked after by his aunt, whilst his mother receives emergency medical treatment. As the boat landed, she had collapsed. (28 October 2015)

23. Most of those landing in Lesvos are soaked by the time their boats reach the beach. With no dry clothes, emergency blankets are their only protection against the cold as they start their journey inland to the first reception points. (28 October 2015)

24. When the refugees land in Lesvos they have little with them. What possessions they had are normally thrown into the sea by the smugglers to allow for more people on the boat. Cold, wet and normally in shock, they have to make the journey to the first registration points on foot, with just emergency foil blankets to protect them from the cold. (28 October 2015)

25. Those landing by boat usual carry three things wrapped carefully in cellophane – their money, papers and phone. Whist his friends mock him, a Syrian refugee dries his money after forgetting to wrap his wallet. (30 October 2015)

26. Many are fully prepared for the journey; others have very little idea of what lies ahead. For this group of Kurds, a tourist map was the first indication that they had landed on an island. (2 November 2015)

27–28. After his boat lost its engine, Amer was rescued along with 40 others after drifting helplessly in the Aegean. They were mainly families from Iraq and Syria who now sat in shock by the harbour. Amer, who is a tailor from the heavily fought over town of Kirkuk took the time to eat his first meal in days. 'I don't understand', he said looking around, 'they are forcing people to go through this and put their lives at risk. It's so undignified. We have the money; why not let us travel legally?' (5 November 2015)

29. Visiting the municipal dump near Molyvos gives a true scale of the crisis. A mountain of life jackets, each jacket represents a life and a story. Shockingly many of the life jackets, bought in Turkey, are fake. (1 November 2015)

30–34. Mytilini cemetery, where many graves are marked simply with a number. (9 November 2015)

Athens, Greece

35. At dawn the ferry from Mytilini arrives in Athens. For the refugees and migrants arriving in Lesvos, this is their only route to mainland Europe. (24 November 2015)

36. Sign outside Refugee Housing Squat Notara 26. (25 November 2015)

37–38. At a squat hosting refugees in Athens, children's drawings recall the horrors they fled in Afghanistan. (25 November 2015)

Idomeni, Greece

39. 2015 saw the return of border restrictions across Europe. Unable or unwilling to deal with

the influx of refugees, asylum seekers and migrants, by the end of the year hastily built fences stretched across the Balkans. In November, following a decision by Macedonian authorities to shut the border only Syrians, Iraqis and Afghans could pass. (28 November 2015)

40. Greek/former Yugoslav Republic of Macedonia border. (28 November 2015)

41. FYR Macedonian military use razor wire to construct a border fence. (29 November 2015)

42. Refugees and migrants queue for food provided by volunteers at Idomeni station. (2 December 2015)

43. As the sun starts to set a Kurdish family from Syria prepares for a night with no shelter on the Greek/former Yugoslav Republic on the Macedonian border. (3 December 2015)

44. Fatima with her father, Mushtaq, who'd worked with the US military in Iraq. They were stuck in Idomeni after FYR Macedonia restricted border crossings. (3 December 2015)

45. Caught at the border, Sara, Mohammad and Asea from Homs, Syria try to keep warm in donated clothes as they prepare for another night without shelter. (3 December 2015)

46. Migrant workers from Pakistan warm their hands against the freezing temperatures. (30 November 2015)

47. Night at the border crossing between Greece and FYR Macedonia. (30 November 2015)

48. Iraqi children street dance waiting at a petrol station where 2,000 refugees were stuck. (6 December 2015)

FYR Macedonia

49. A train carrying Iraqi, Syrian and Afghan refugees (28 November 2015)

50. A refugee peers from a train in FYR Macedonia. I asked a young Syrian man why he had travelled to Europe when many of his friends and family had stayed. 'It's simple.' He replied, 'I was the first to give up hope. I was the first to realise there is no more Syria.' (28 November 2015)

Berlin, Germany

51. 'Refugees Welcome' graffiti at the YAAM club. Whilst there has been much hostility, often violent toward refugees across Europe, one of the lasting impressions I have is of the volunteers making them feel welcome. From saving lives on the beaches of Lesvos, to cooking 'Welcome' dinners in Berlin, everyday people have stepped up where often governments have failed. (26 December 2015)

52. The distance from Damascus to Berlin via Lesvos is 4,500km, and from Kabul 7,700km. After a journey that has taken months, dealing with smugglers, the crossing of the Aegean by boat, borders, nights without shelter, days without food, some refugees arrive at Schonefeld Station in Berlin. The last part of their journey was dubbed 'the train of hope'. (27 December 2015)

53. Iraqi, Syrian and Kurdish children play outside their hostel in Schonefeld. (27 December 2015)

54. Hassan, who is just 14, is one of the thousands of minors who make the perilous journey through Europe unaccompanied. Normally the family can't afford for everybody to travel, or other family members are too weak or vulnerable. Hassan's family were desperate for him to get an education and hoped that at least he would have a future. (26 December 2015)

55. On Christmas Day, at a meal organised by volunteers in Berlin, Bahjat a Syrian refugee, shows footage he filmed when crossing by boat to Lesvos. As he filmed his journey across the Aegean, I had been on the shore photographing the boats arriving. (25 December 2015)

56. A Syrian refugee with the wristband he has had to wear to gain access to his camp. For many it's a stigma that identifies them as refugees when they are out in Berlin. (26 December 2015)

57. Struggling to find accommodation for the one million refugees and asylum seekers that have entered Germany in the past twelve months, the authorities have been using abandoned and vacant buildings across the country. The irony of refugees living in the Tempelhof, the former airport and symbol of Hitler's 'world capital' Germania, is not lost on those who are now housed there. (23 December 2015)

PART II

Shelter:
Iraq, Lebanon, Jordan

Dec 2015–June 2016

Bekaa Valley, Lebanon.

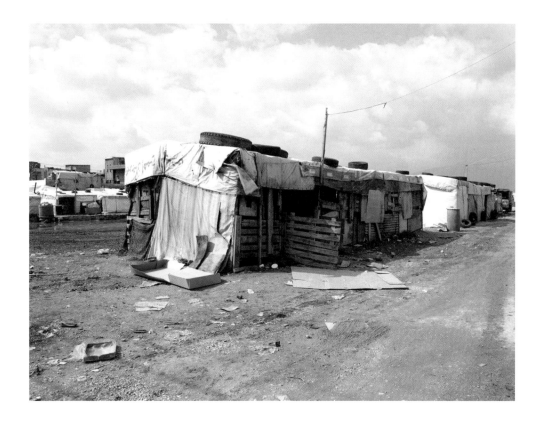

Bekaa Valley, Lebanon.

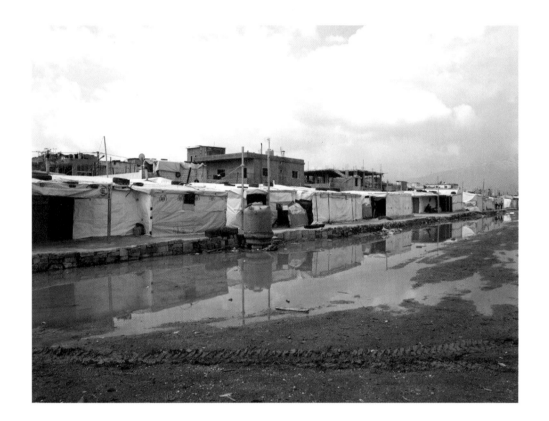

Bekaa Valley, Lebanon.

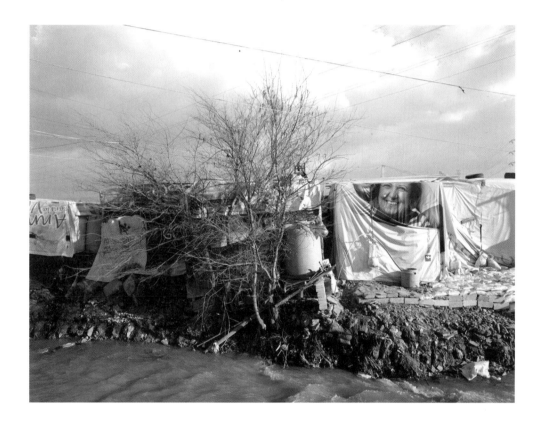

Tripoli, Lebanon.

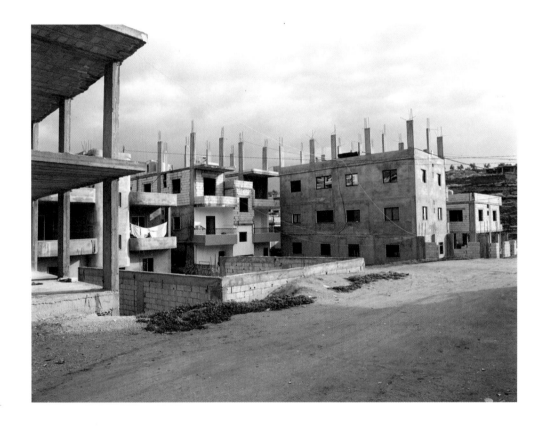

Mafraq, Jordan.

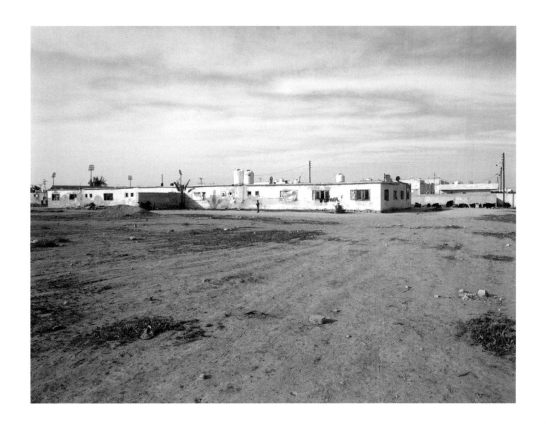

Mafraq, Jordan.

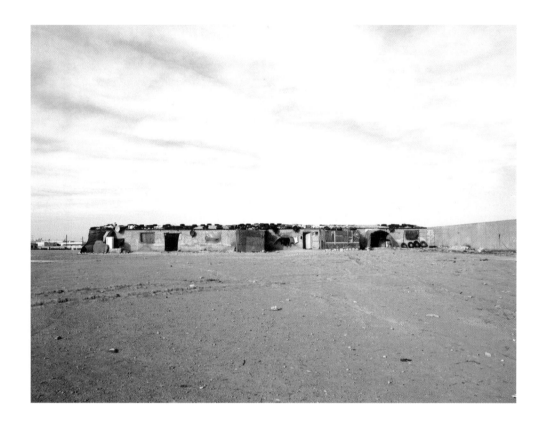

Mafraq, Jordan.

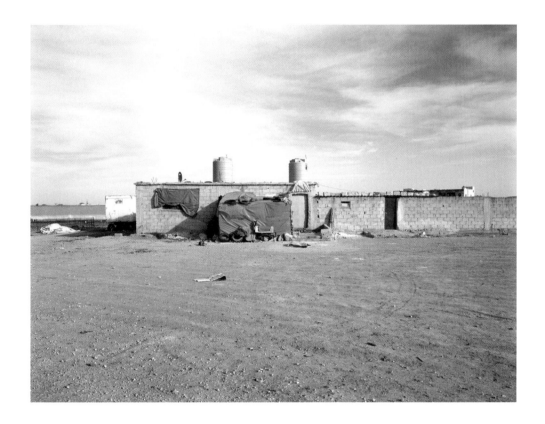

Zaatari Camp, Jordan.

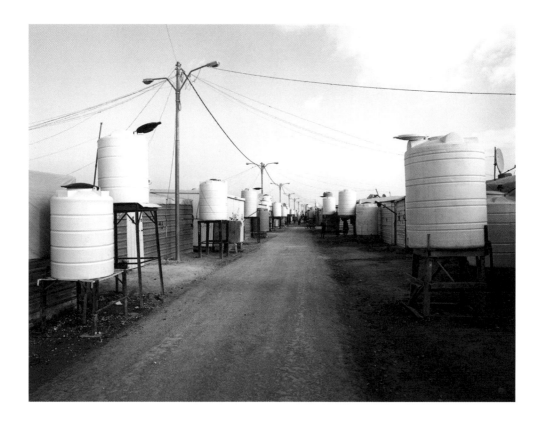

Zaatari Camp, Jordan.

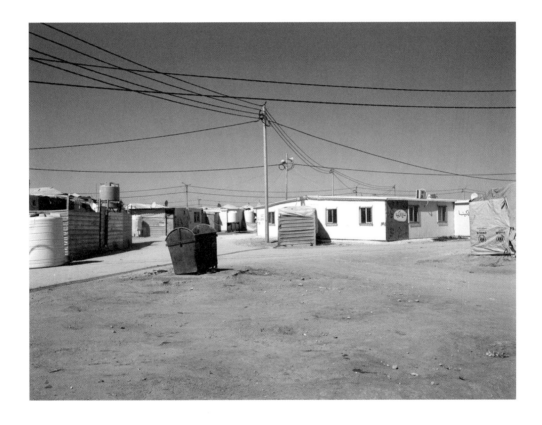

Zaatari Camp, Jordan.

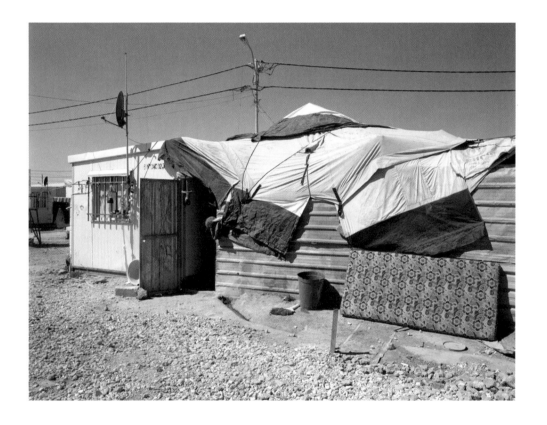

Zaatari Camp, Jordan.

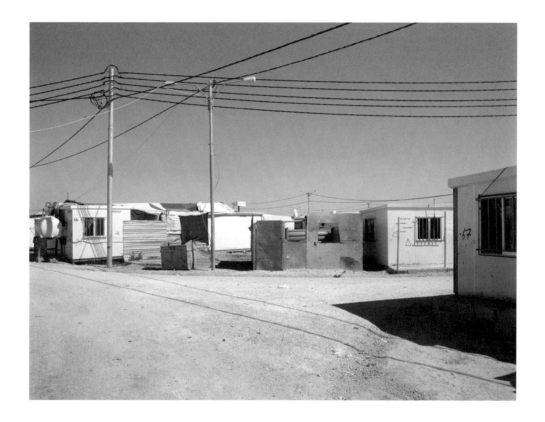

Zaatari Camp, Jordan.

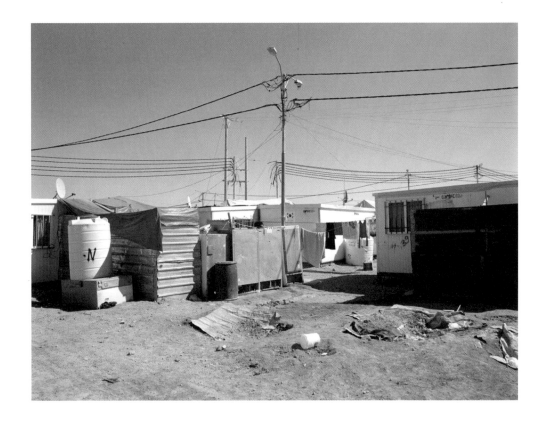

Zaatari Camp, Jordan.

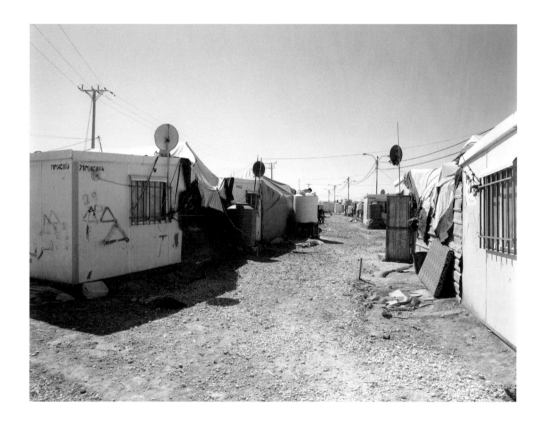

Zaatari Camp, Jordan.

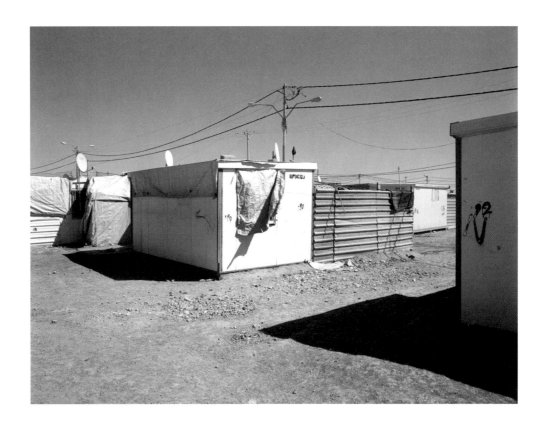

Zaatari Camp, Jordan.

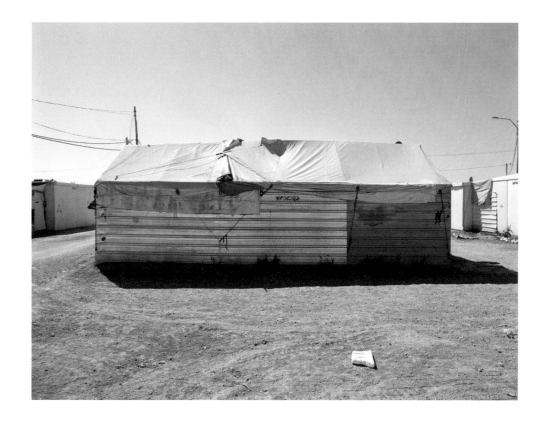

Domiz Camp, Duhok, Northern Iraq.

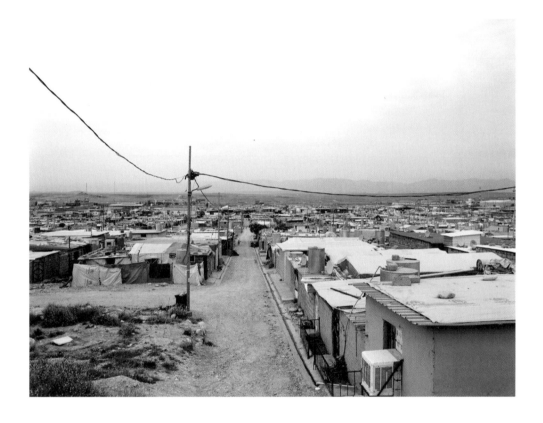

Domiz Camp, Duhok, Northern Iraq.

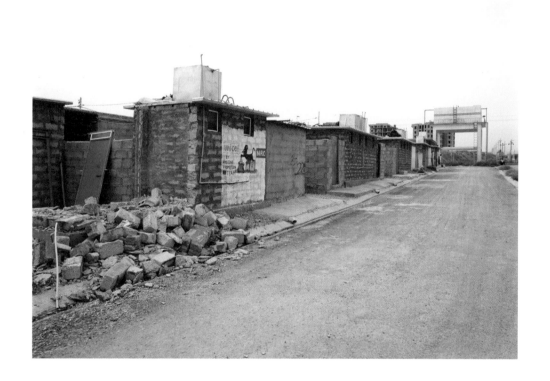

Domiz Camp, Duhok, Northern Iraq.

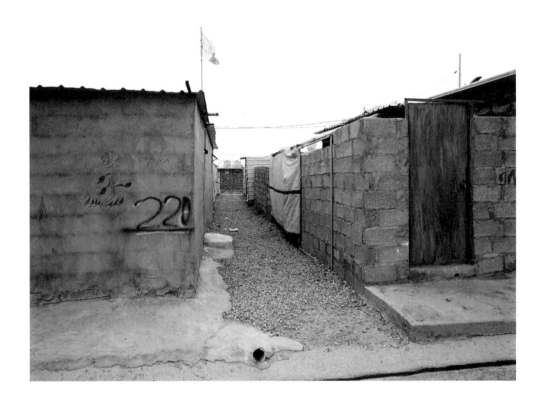

Domiz Camp, Duhok, Northern Iraq.

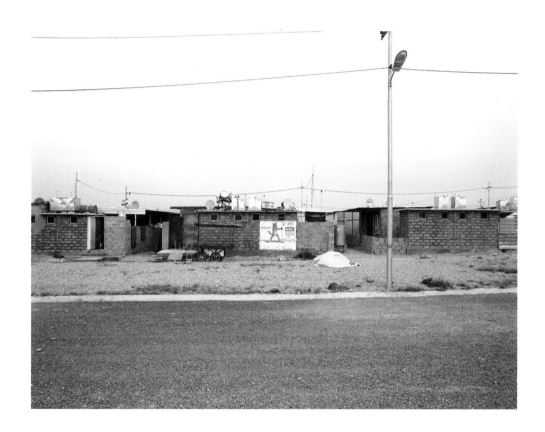

Domiz Camp, Duhok, Northern Iraq.

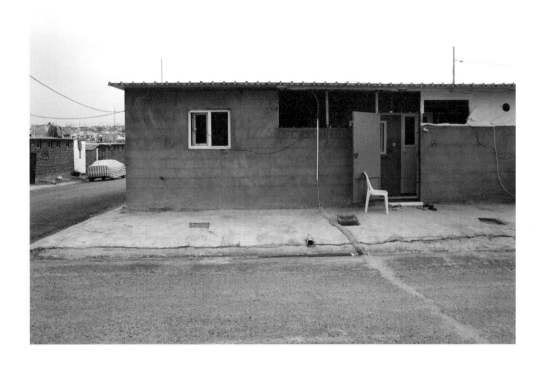

Domiz Camp, Duhok, Northern Iraq.

Domiz Camp, Duhok, Northern Iraq.

Domiz Camp, Duhok, Northern Iraq.

Domiz Camp, Duhok, Northern Iraq.

Waar City, Duhok, Northern Iraq.

Waar City, Duhok, Northern Iraq.

PART III

Portraits:
Iraq, Lebanon, Jordan

Feb–June 2016

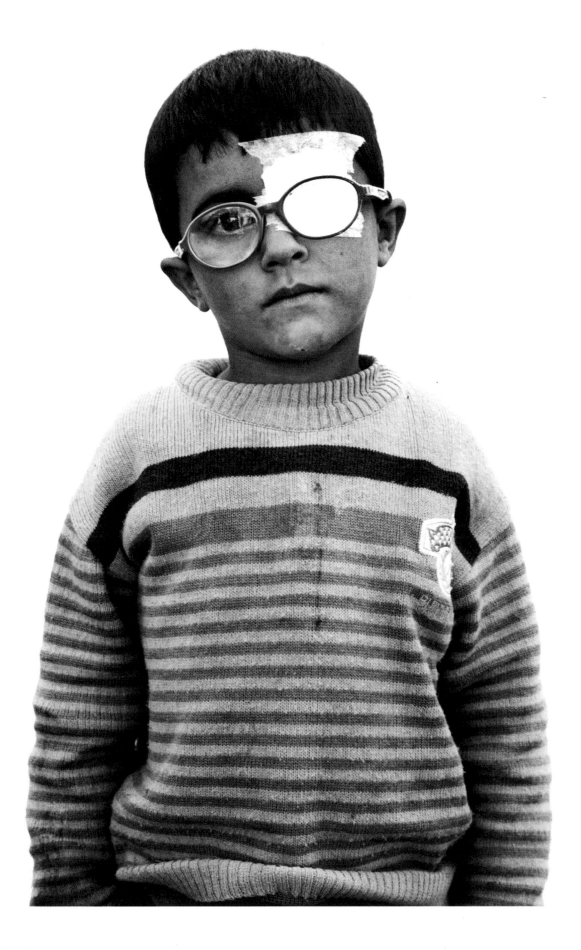

Murad

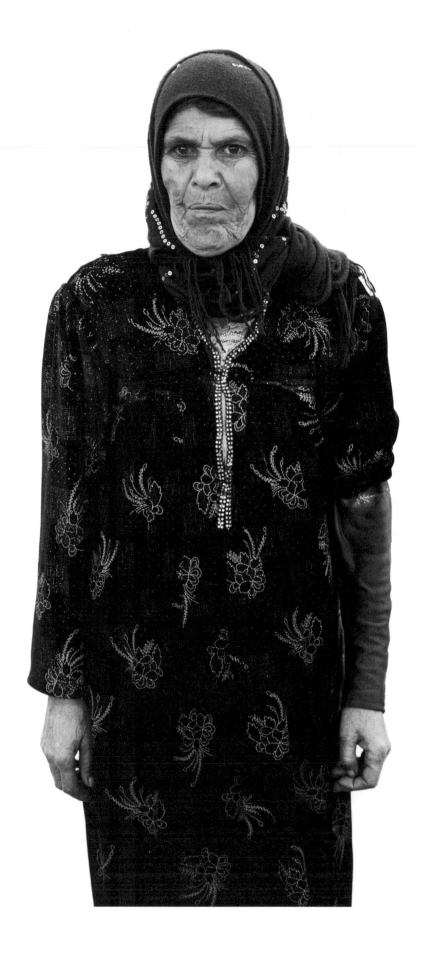

Kraymeh

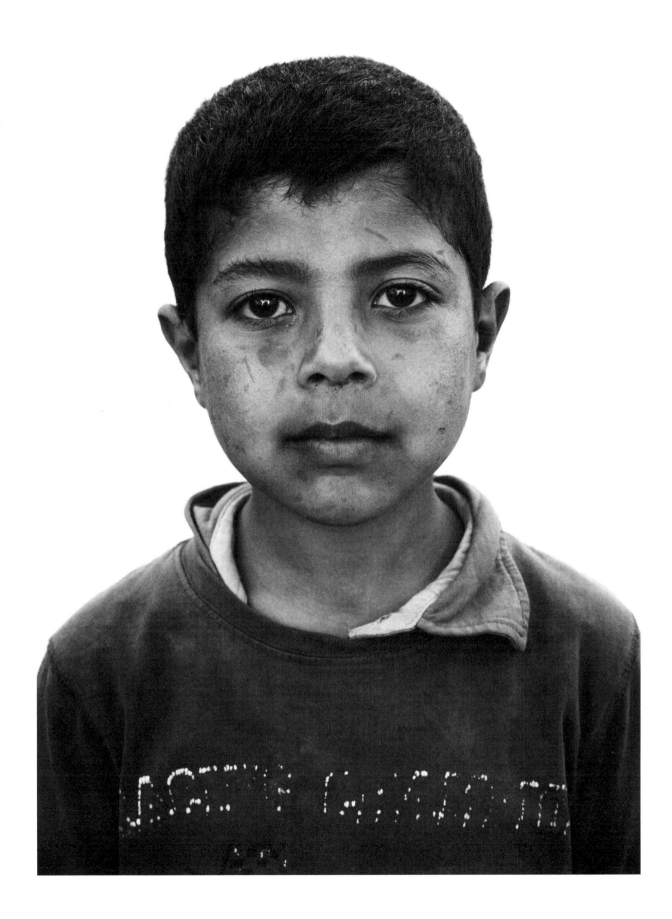

Hussein

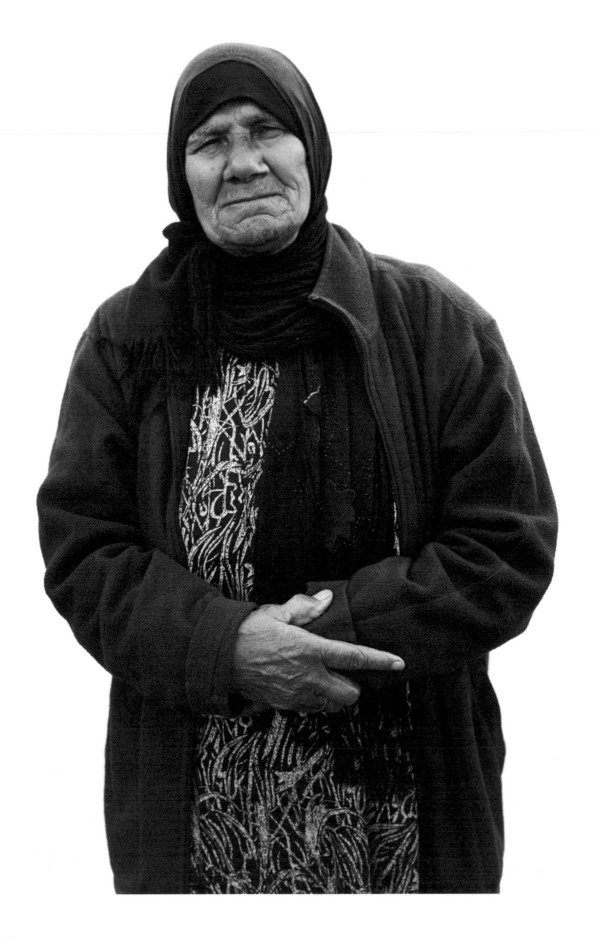

Halima

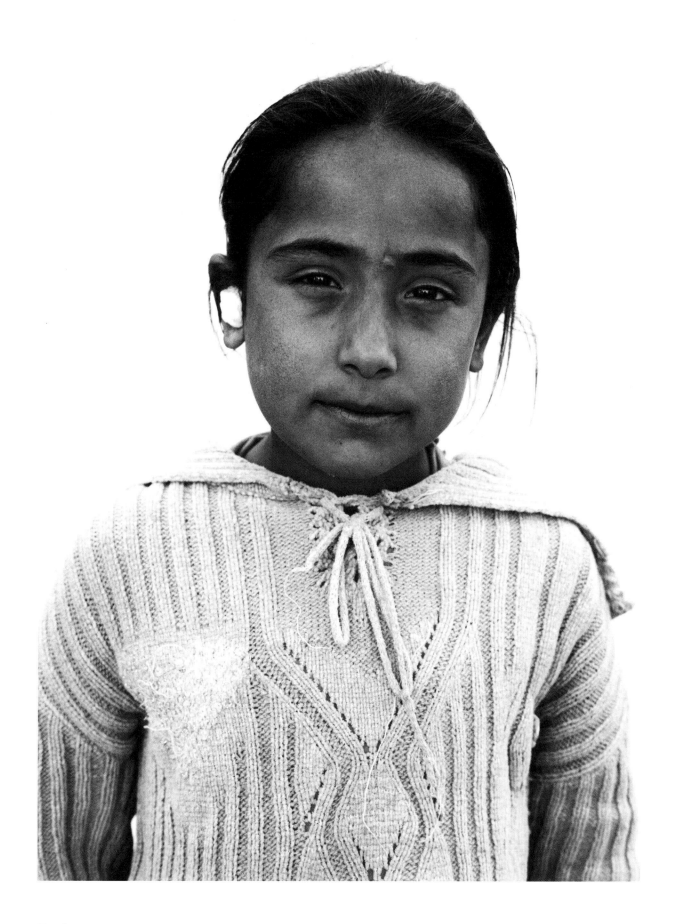

Ranim

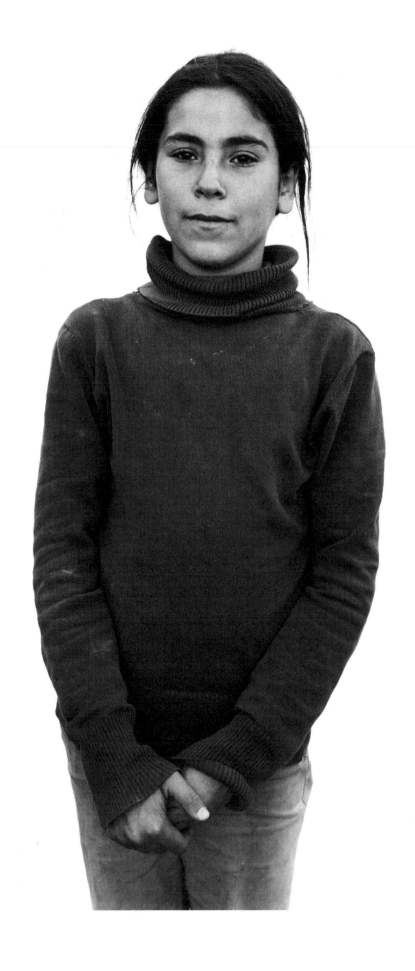

Khadisha

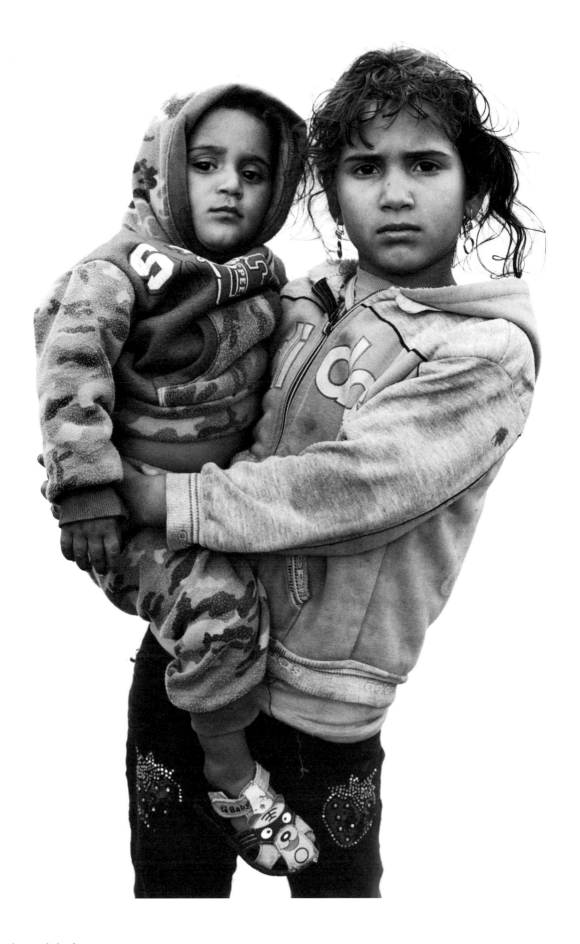

Lamis and Jad

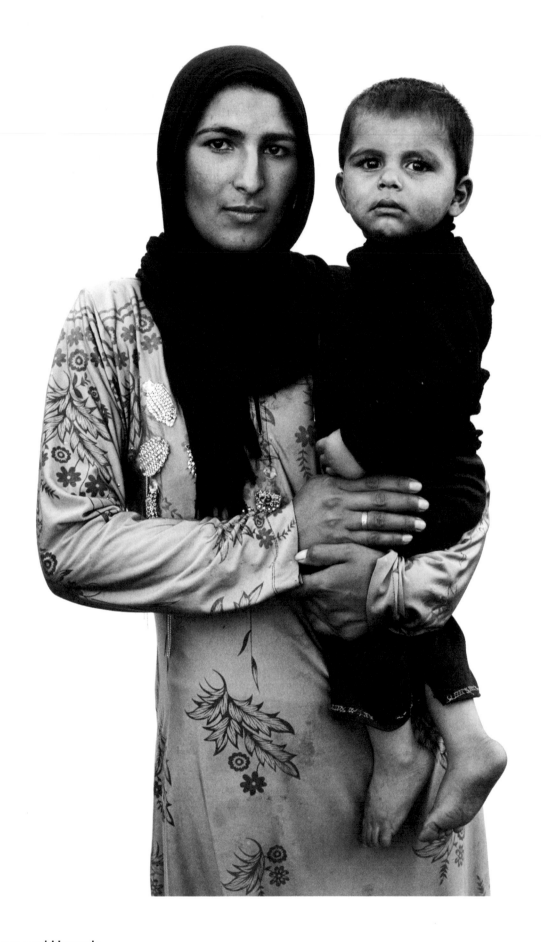

Hanan and Hussein

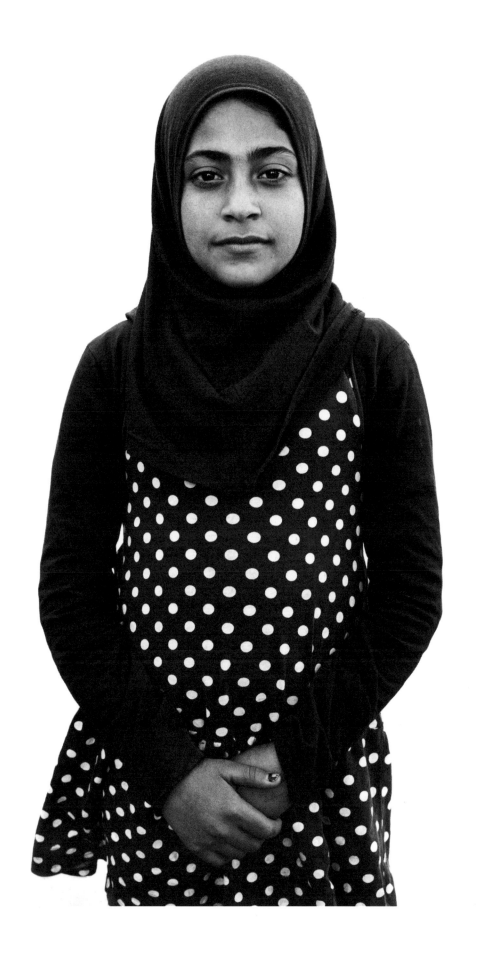

Rana

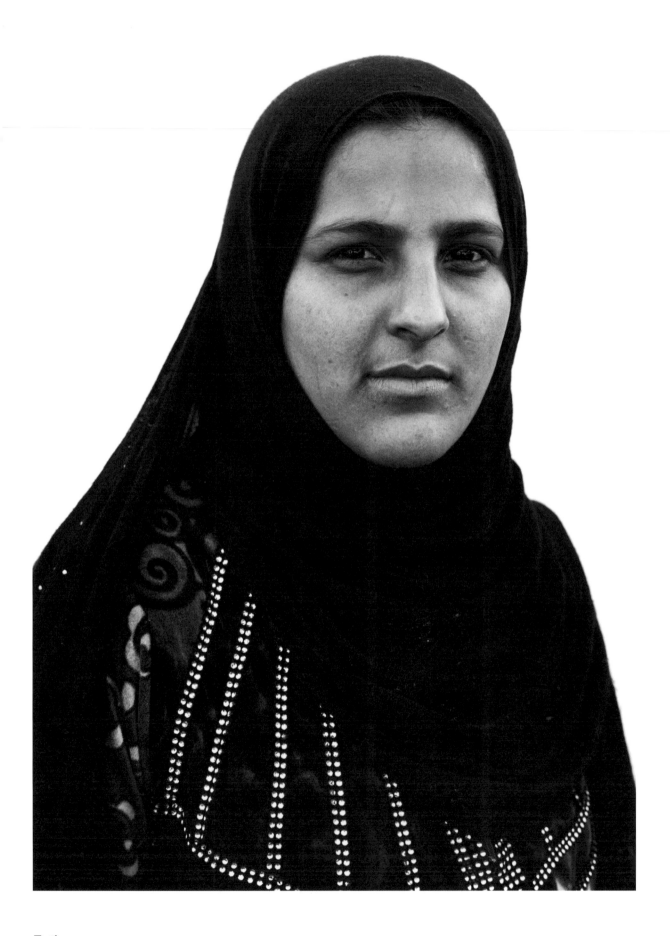

Fatima

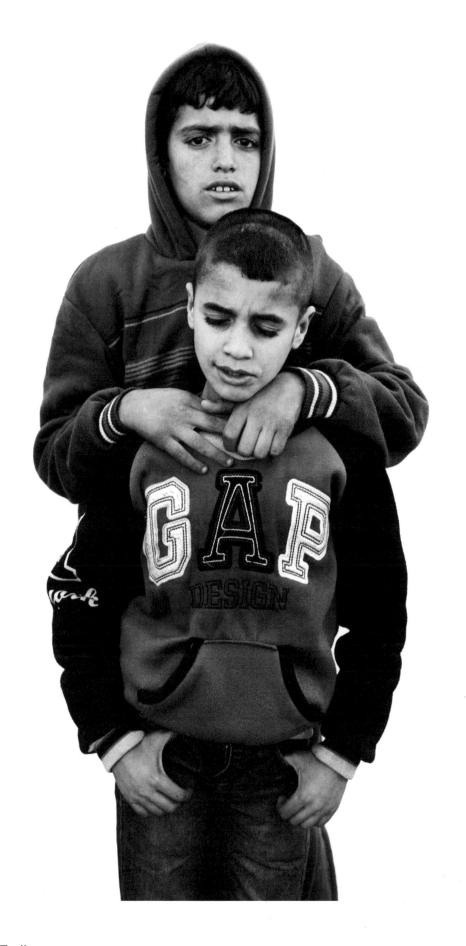

Khaled and Fadi

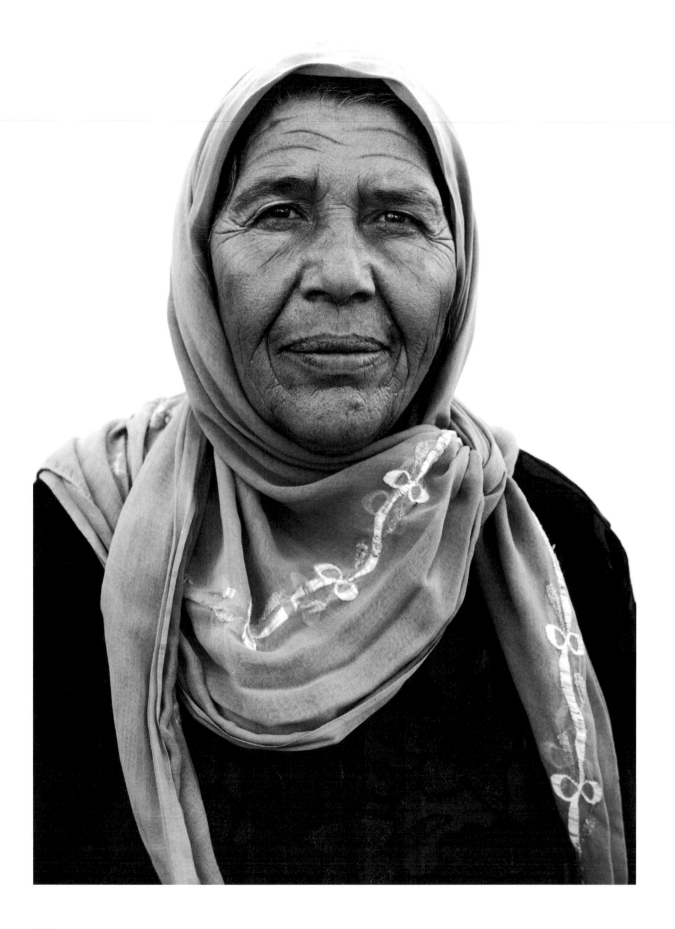

Zahra

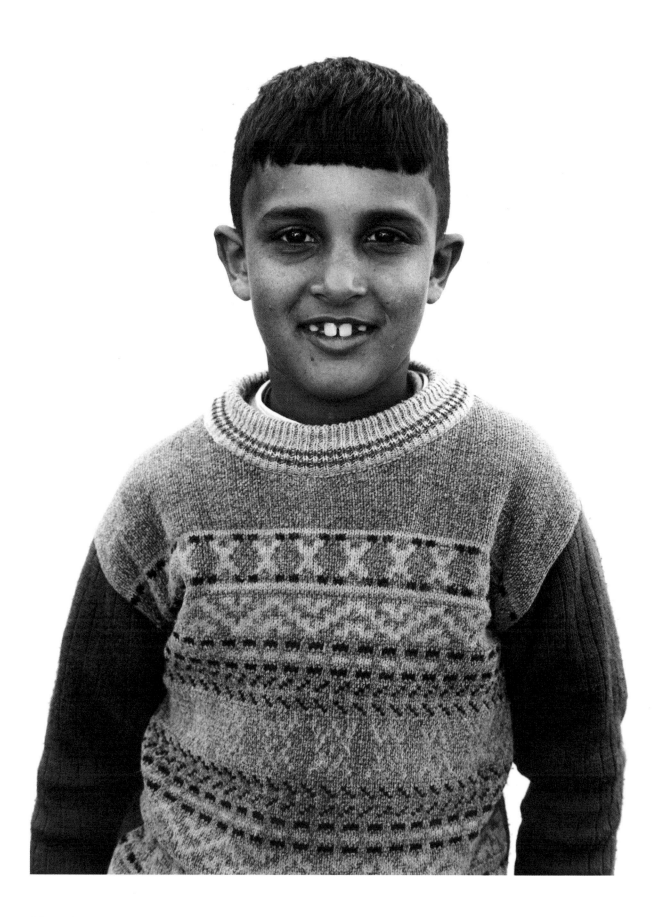

Ahmad

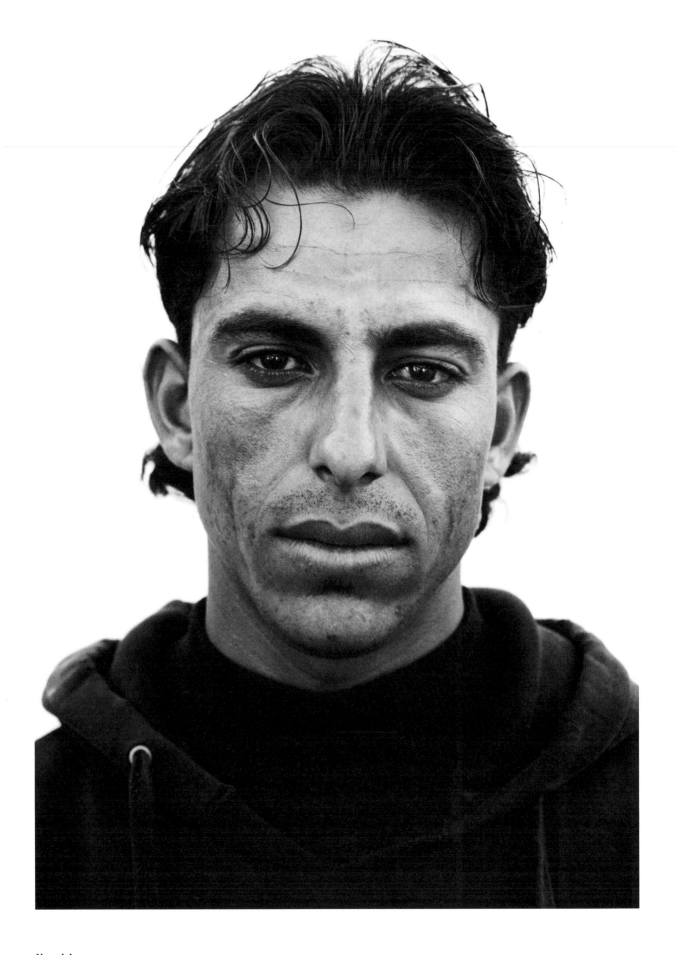

Ibrahim

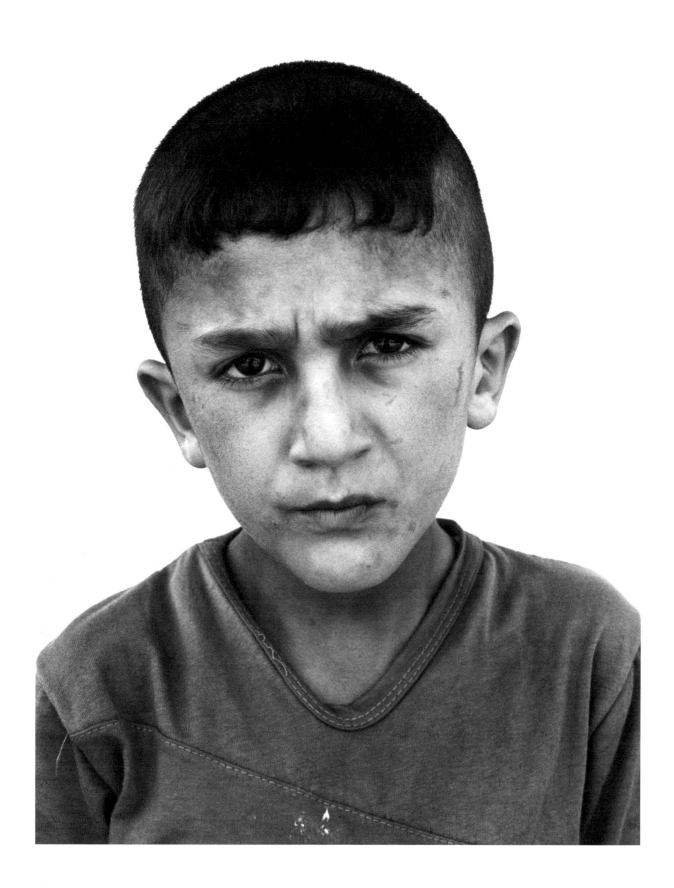

Ahmed

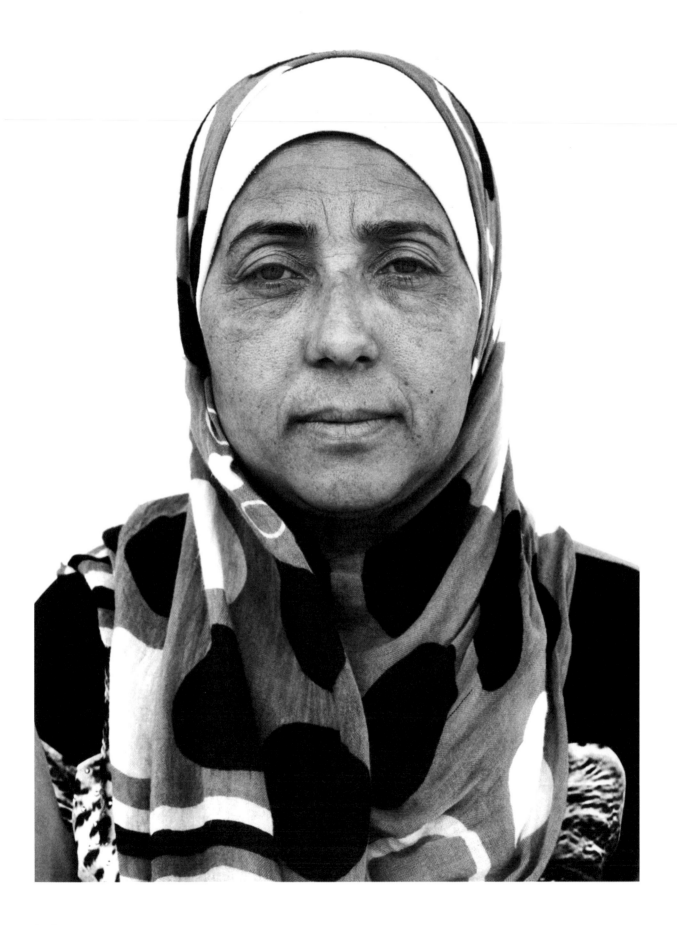

Indera

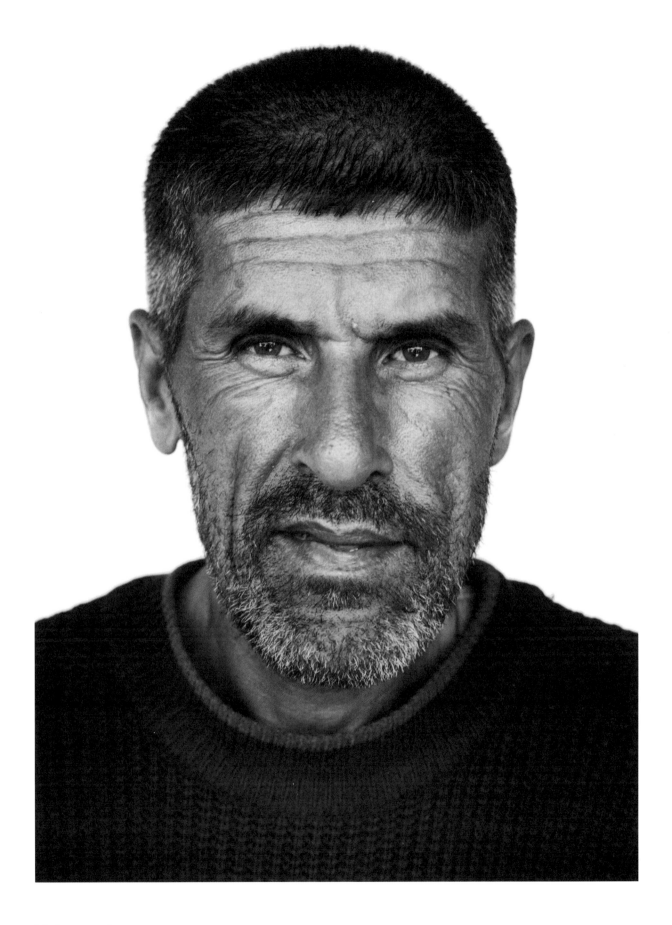

Mohammad

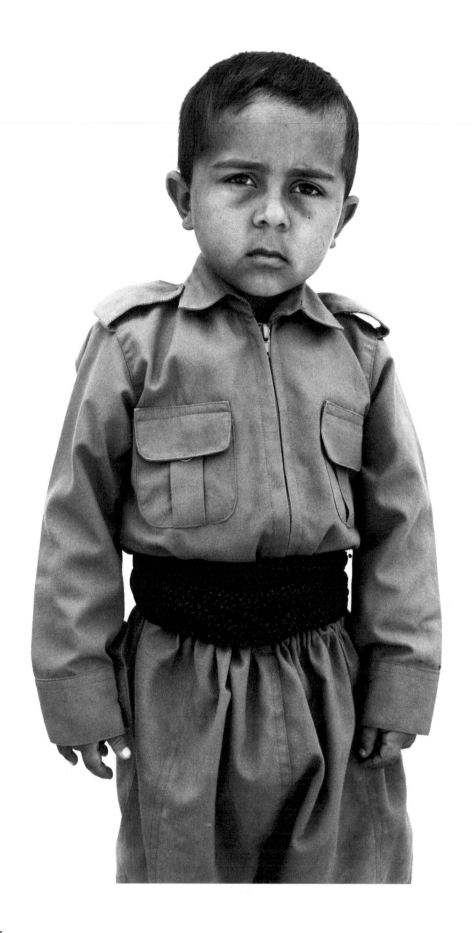

Shavgar

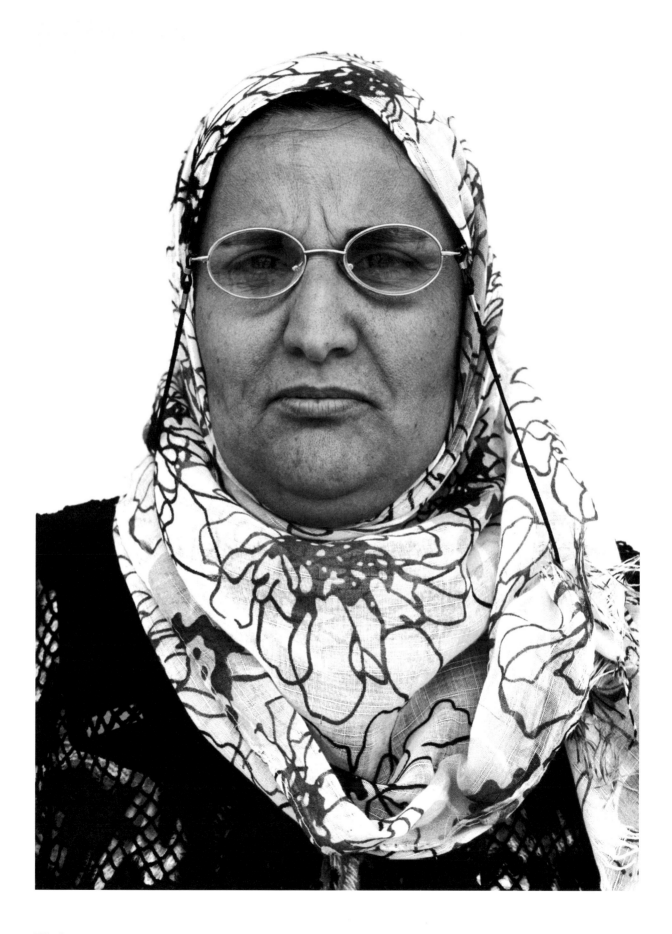

Thabat

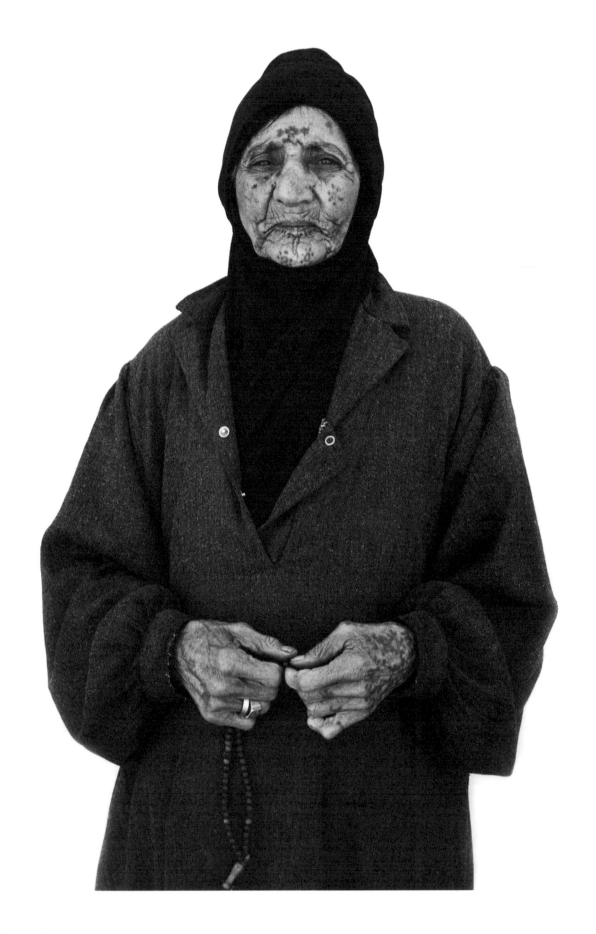

Shamah

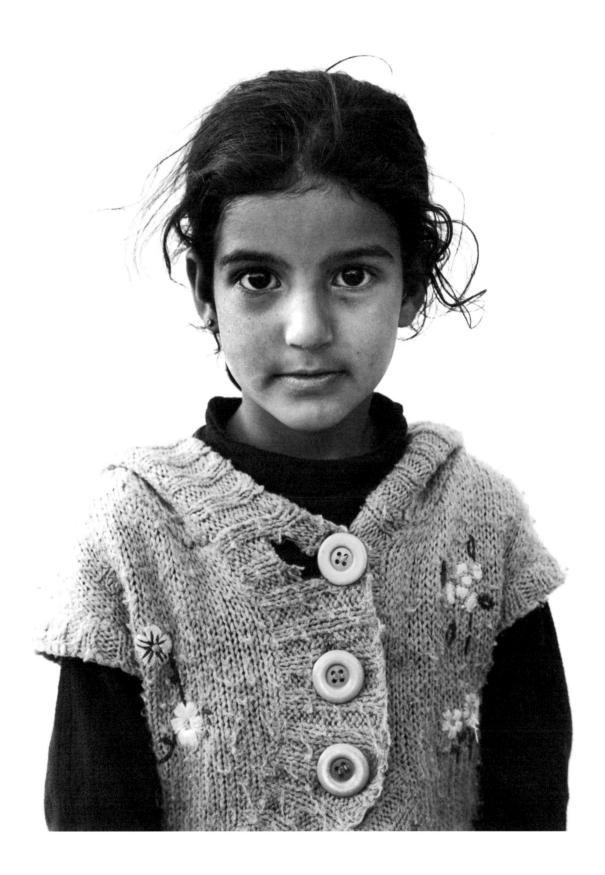

Nuwar

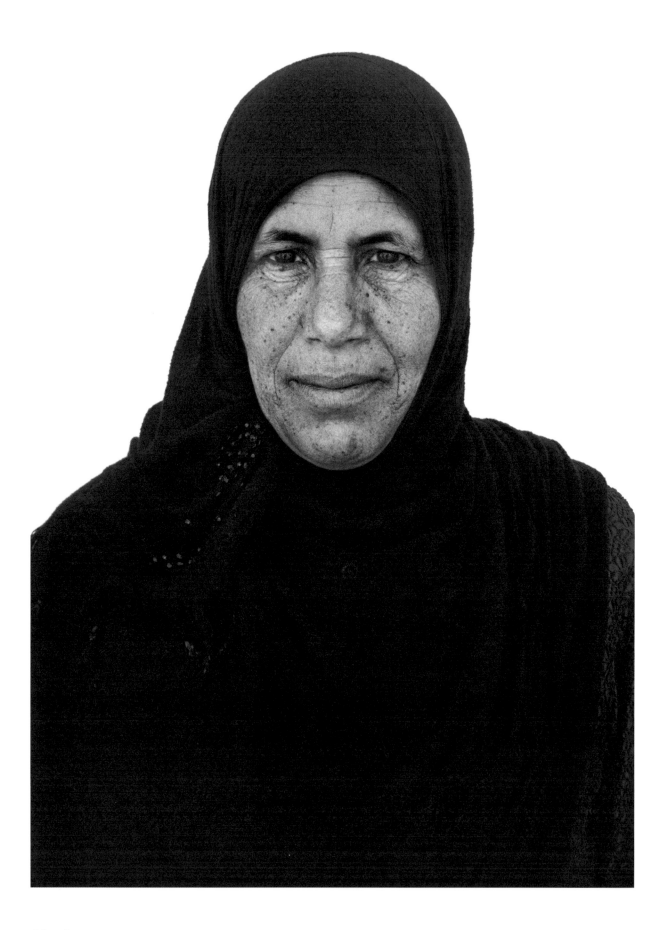

Ghazia

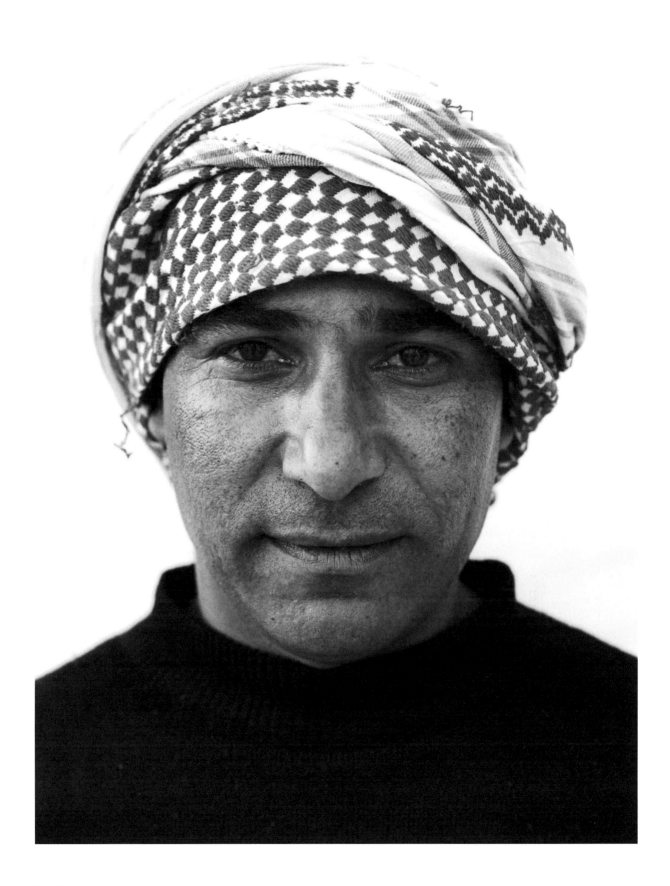

Nasir

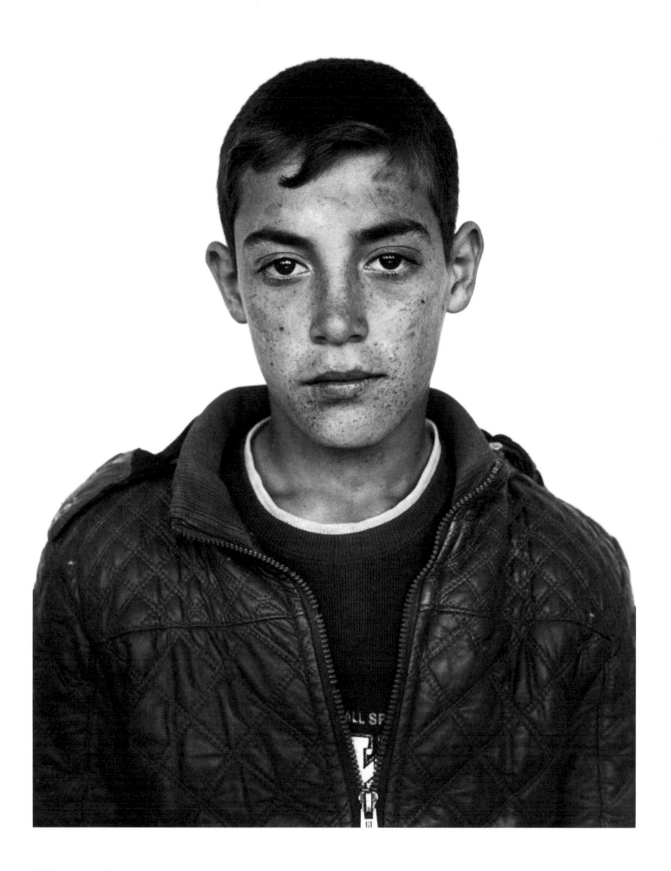

Mohammad

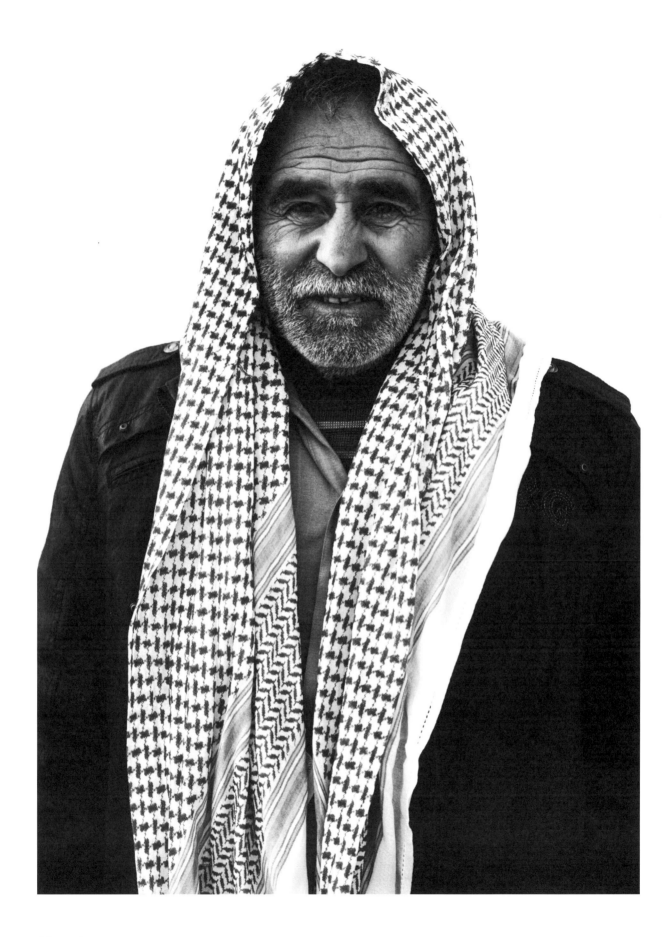

Ahmad

Bekaa Valley, Lebanon. February 2016:

1. Murad, 5 years old, from Idlib.
2. Kraymeh, 50 years old, from
 Sarajeb in countryside of Idlib.
3. Hussein, 8 years old, from
 Al Bab near Aleppo.
4. Halima, 60 years old, from Idlib.
5. Ranim, 7 years old, from the
 countryside near Idlib.
6. Khadisha, 10 years old, from the
 countryside near Aleppo.
7. Lamis, 5 years old, with her
 brother Jad, I year old, from Homs.
8. Hanan, 20 years old, from Idlib,
 with her son Hussein, 2 years old.
9. Rana, 10 years old, from the
 countryside near Idlib.
10. Fatima, 25 years old, from Aleppo.
11. Khaled, 12 years old, and his
 brother Fadi (blind), who
 is 7 years old, from Homs.
12. Zahra, 54 years old, from
 Abou Dhour, the countryside
 near Idlib.
13. Ahmad, 8 years old, from Idlib.
14. Ibrahim, 25 years old, from Idlib.

Domiz Camp, Dohuk, N.Iraq. April 2016:

15. Ahmed Murad, 5 years old, from
 Qamishlu.
16. Indera Hassan, 29 years old,
 from Damascus.

Zaatari Camp, Jordan. March 2016:

17. Mohammad Amin, 49 years old,
 from Daraa.

Domiz Camp, Dohuk, N.Iraq. April 2016:

18. Shavgar, 4 years old, from
 Damascus.
19. Thabat Hasan, 44 years old,
 from Qamishlu.

Al-Mafraq, Jordan. March 2016:

20. Shamah Darweesh, over 90 years
 old, from Homs.
21. Nuwar, 6 years old, from Homs.
22. Ghazia Al-Salman, 50 years old,
 from Homs.
23. Nasir Jasim, 32 years old,
 from Homs.
24. Mohammad Hussein, 14 years
 old, from Daraa.
25. Ahmad Khlaif, 67 years old,
 from Homs.

PART IV

Families:
Lebanon, Jordan, France

Jan–July 2016

'The day was peaceful. It had been snowing, but that was the first day of sun. So we went on the rooftop. There was no shelling. We sat in the sun. Then four rockets landed.'

It would be two months before Areej regained consciousness and learnt that two of her daughters had been killed that day. Her son Muhammad had lost his leg and one of her other daughters, Bathoul, an eye.

Now the family lives in one room of a house in Jordan. Her husband Ibrahim, a long distance lorry driver, just wants to return to work so he can support the family.

Ajloun, Jordan. March 2016

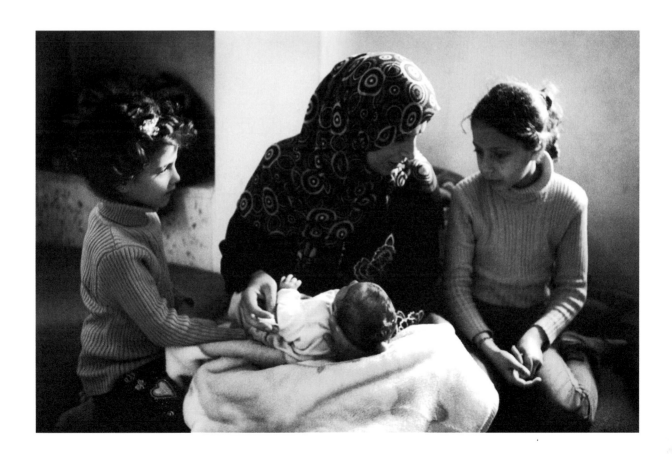

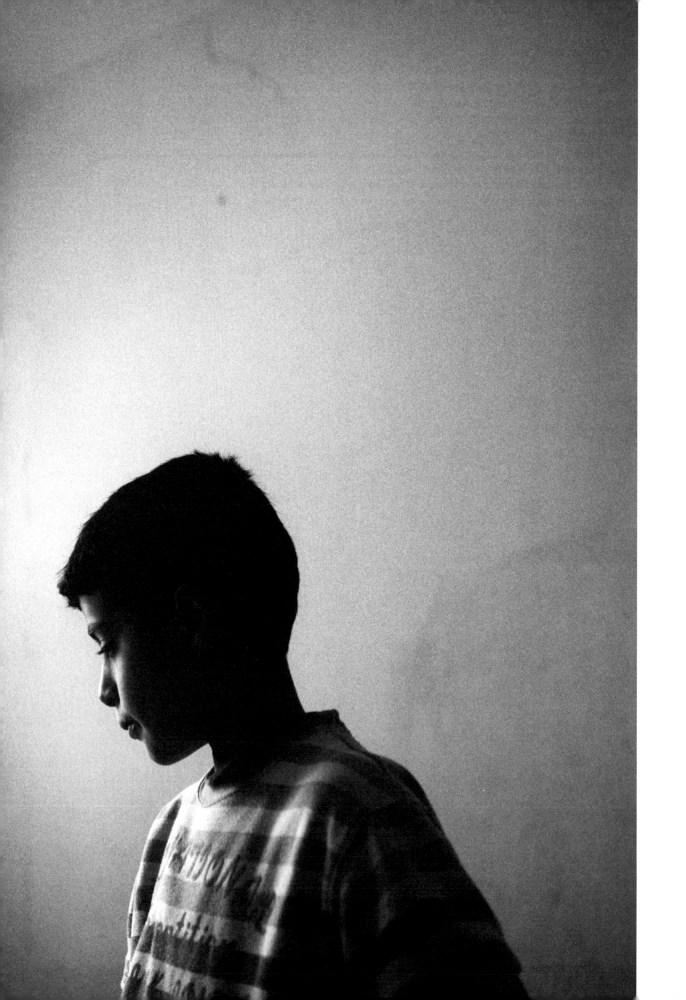

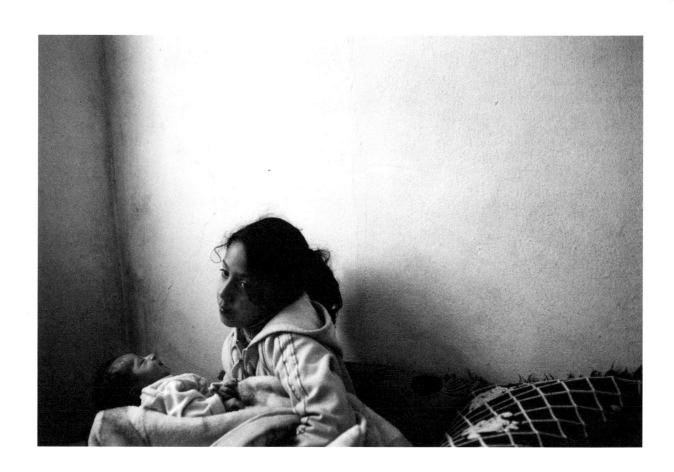

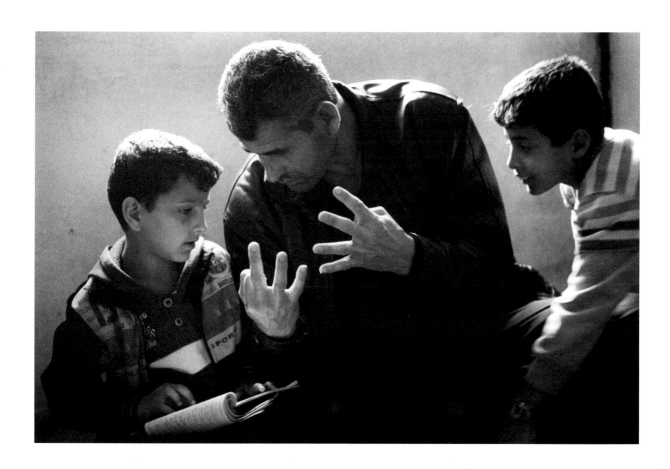

An extended family from Homs found refuge in abandoned buildings on the edge of Mafraq. Choosing not to live in the nearby camp of Zaatari, the community has a large number of children, the elderly and disabled.

'We don't want to go to Europe,' explains Otour, one of three matriarchs, 'we don't want to be in Jordan either, or a camp that takes our freedom. We will never have any home other than Syria.'

Mafraq, Jordan. March 2016

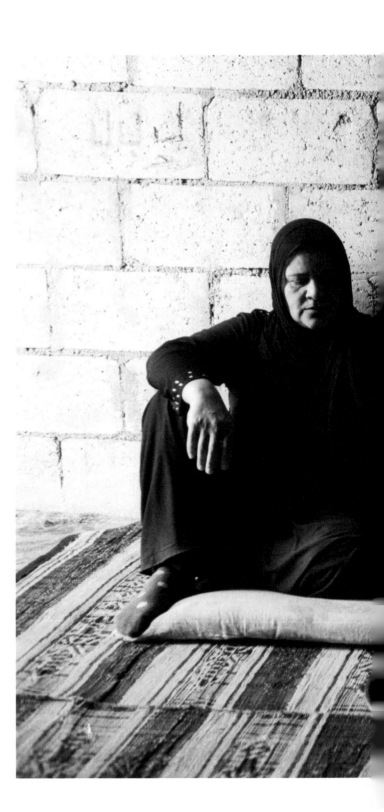

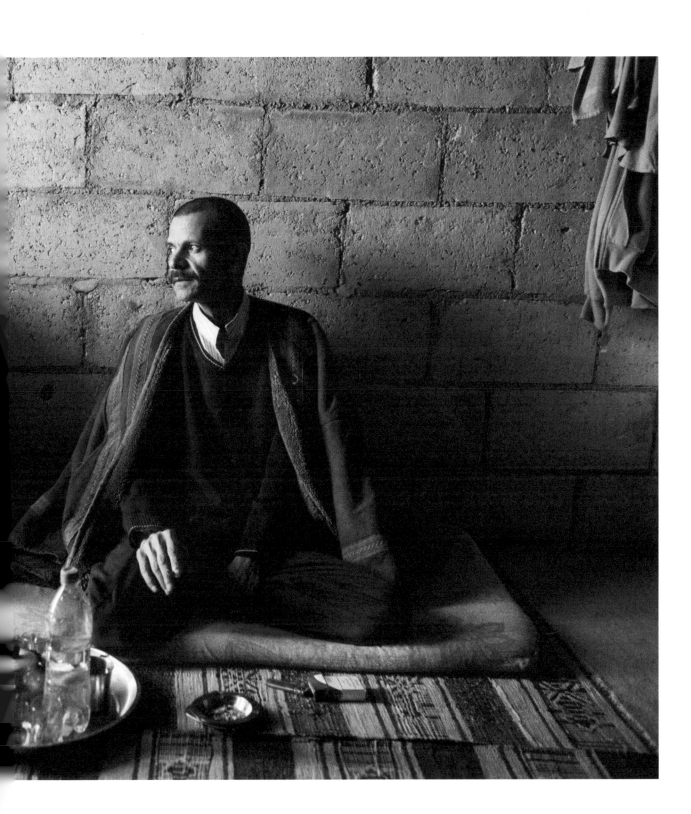

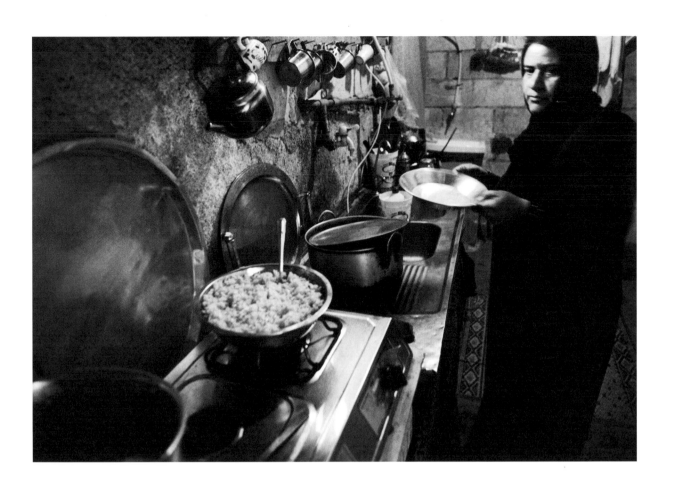

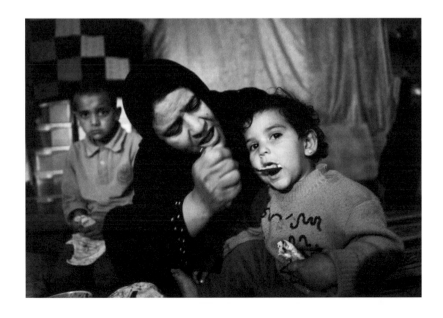

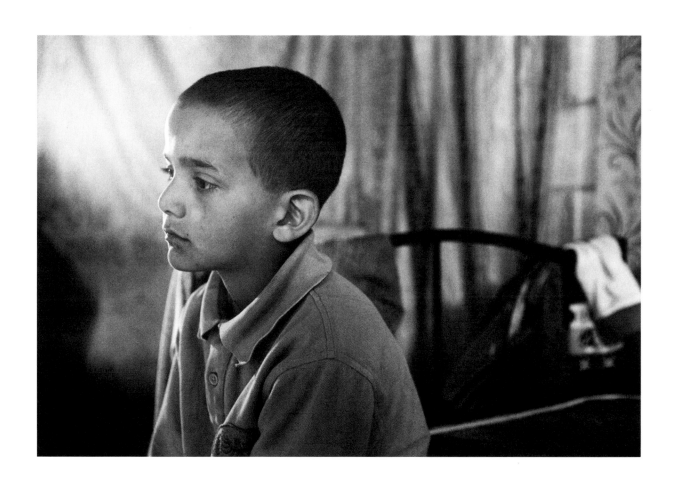

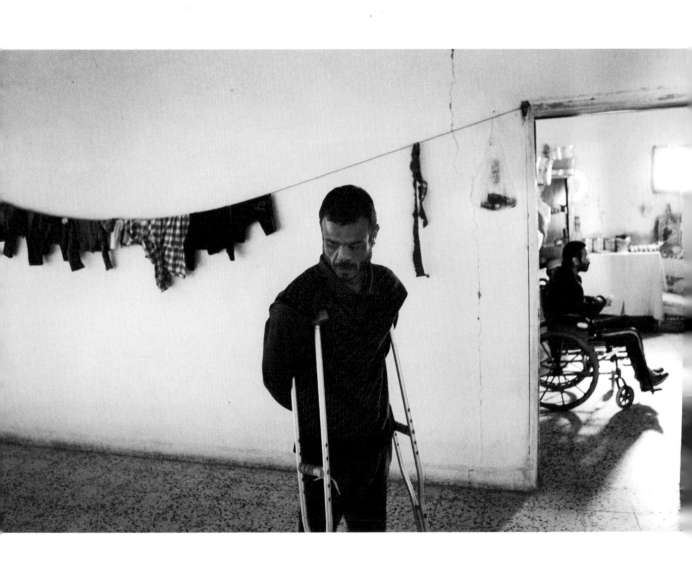

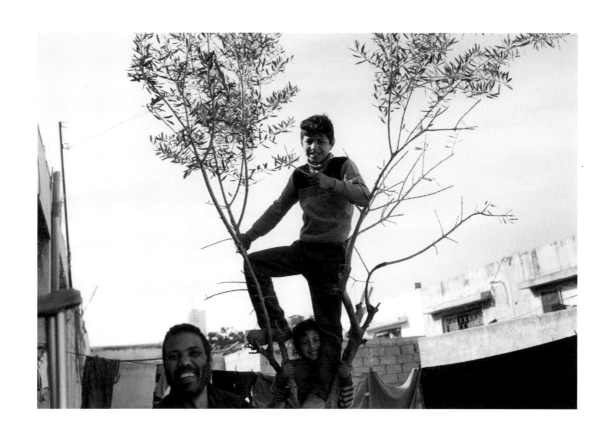

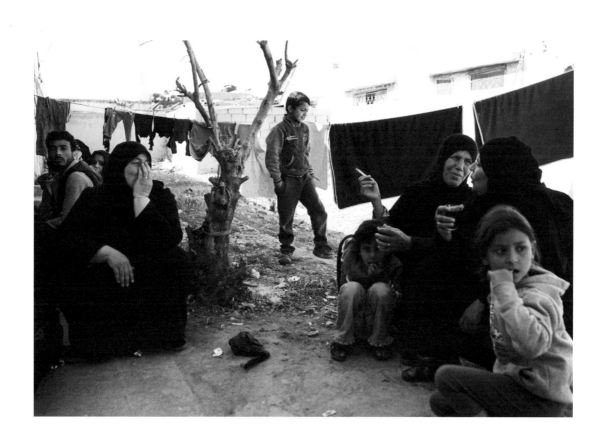

Reem sought refuge in Lebanon after her house was hit by a rocket. Her husband was killed in the bed next to her, one of her daughters was killed and Reem herself lost a leg.

At the time, the only place she could find to live was with her father Abdel on the top floor of an unfinished building in the Bekaa Valley. Due to her injuries, it took her over a year to be able to use the stairs.

Her other daughter, Sarah, now lives with her on the rooftop, along with her father, brother Imad and sister-in-law Hanan. It has been four years since Sarah attended school.

Zahle, Bekaa Valley, Lebanon. February 2016

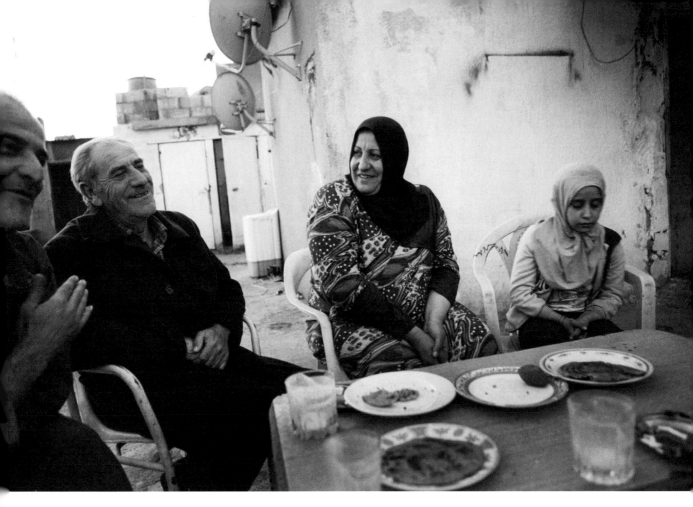

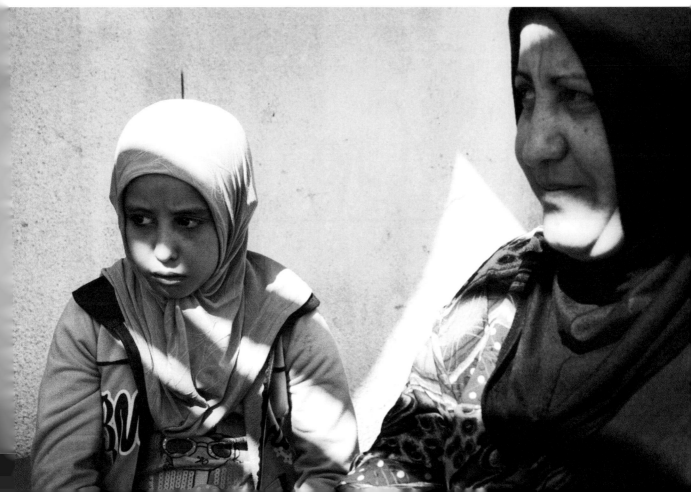

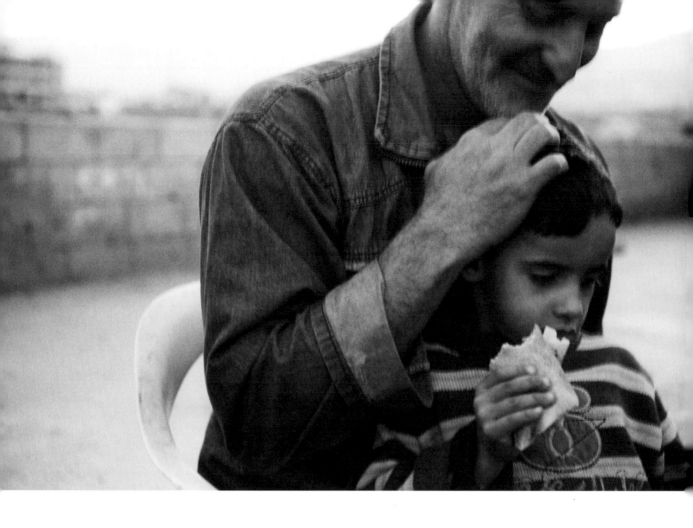

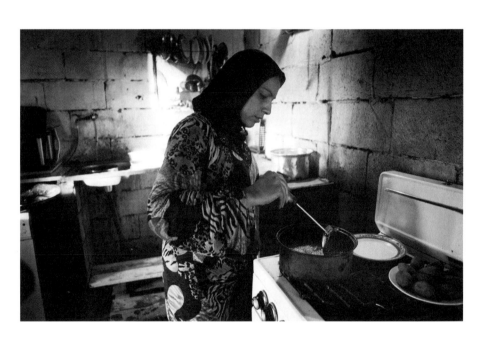

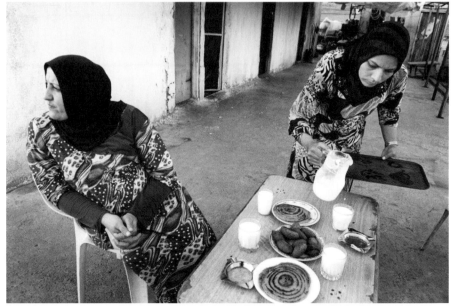

Khouloud lives in a makeshift tent in the Bekaa Valley with her husband Jamal and four children, Hamaz, Aya, Muhammad and Khalil. In 2013, while working in her garden, a sniper shot her through the spine leaving her paralysed from the neck down.

For the past two and a half years, Khouloud has remained in bed, trapped in the same windowless room. Jamal is her full time carer. When I asked her, 'What's your hope for the future?', 'To be a mother again,' she replied simply. 'To be a mother again.' Yet despite untold suffering and her constant pain, the family has a resilience and bond that is truly remarkable. It's a place full of love and laughter.

Bar Elias, Bekaa Valley, Lebanon. February 2016

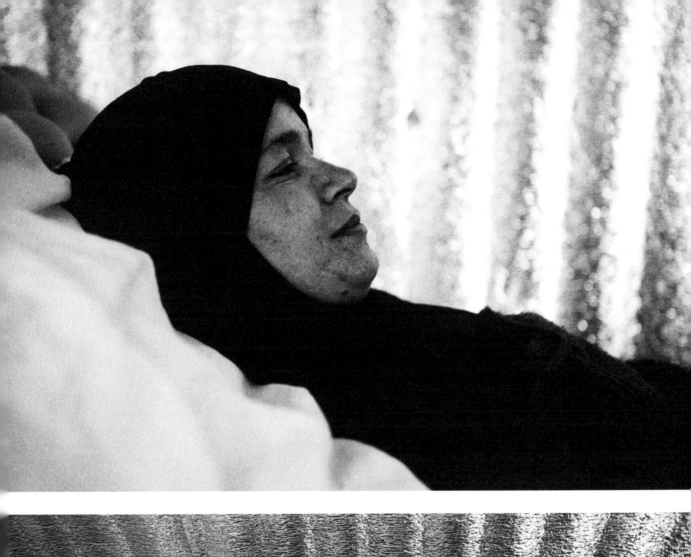
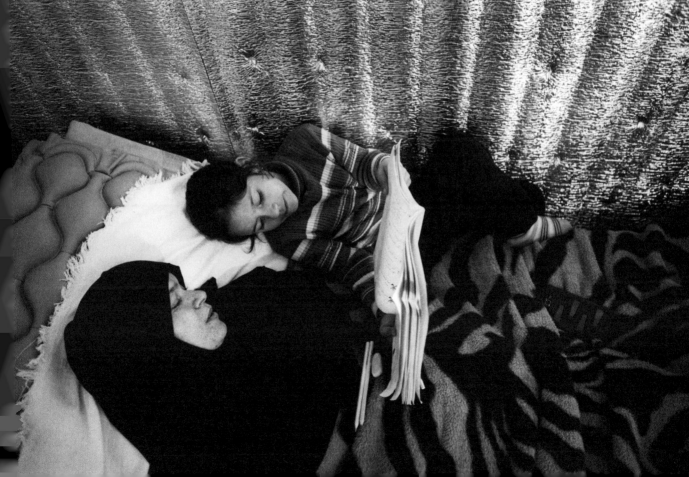

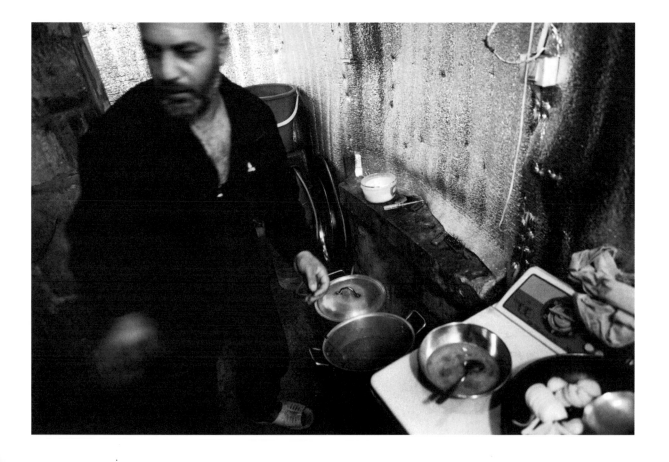

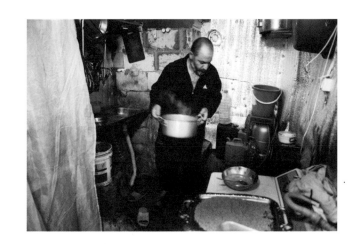

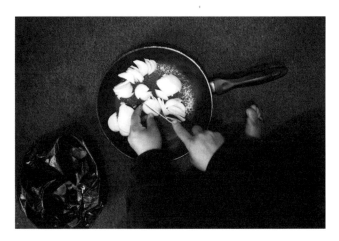

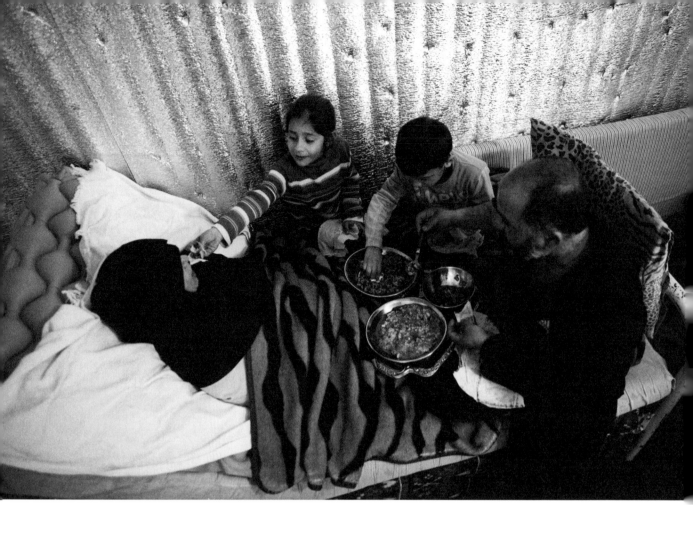

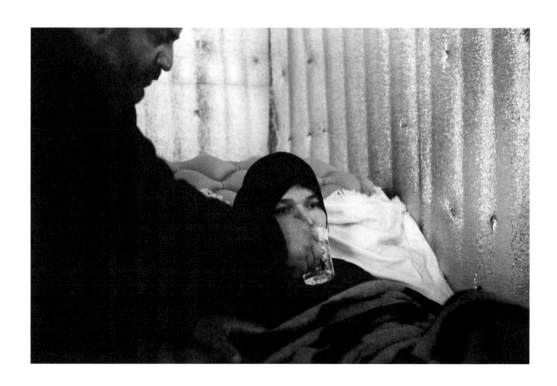

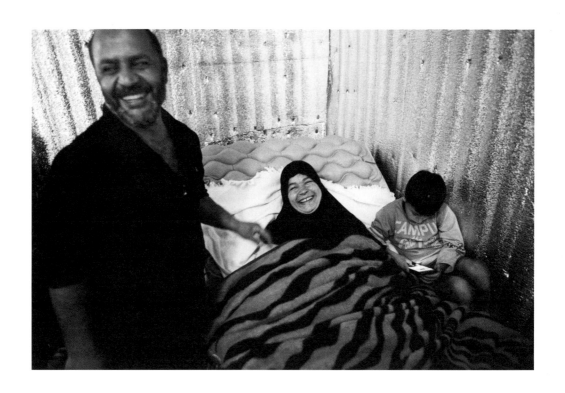

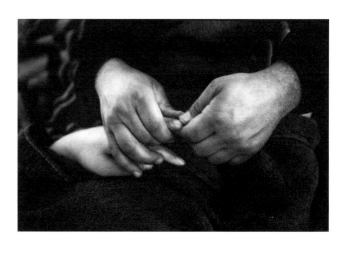

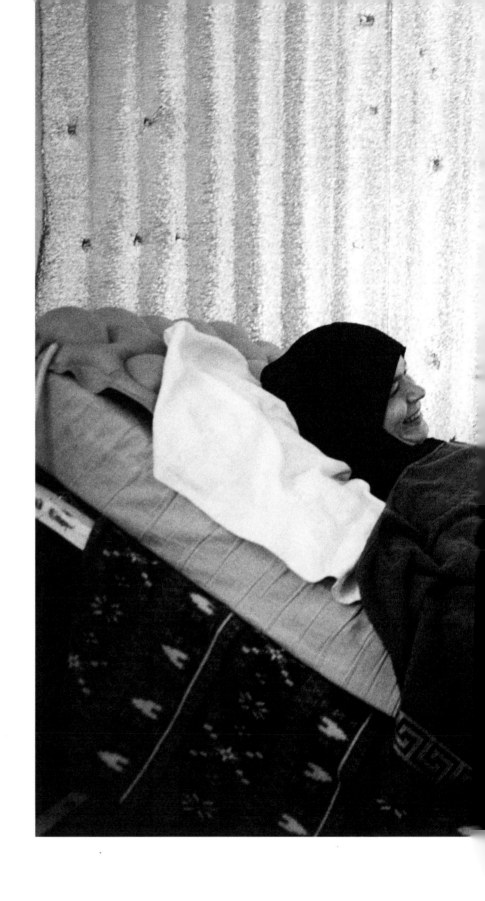

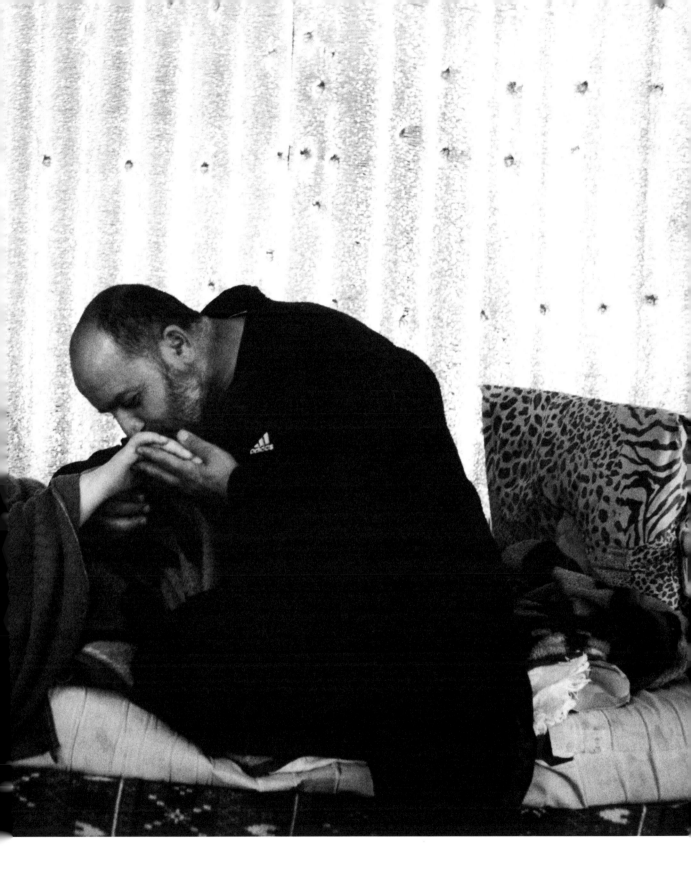

After their house in Idlib, Syria, was destroyed in 2012, Aya and her family fled to Lebanon where for two years they lived in a makeshift tent next to a cement factory. The children suffered from breathing problems and were often sick. Eventually they were moved to an unfinished building on the outskirts of Tripoli.

Aya, 7, has spina bifida, and without constant medical support and suitable living conditions, her life was constantly under threat. In Tripoli the family waited in limbo. Aya's parents Sihan and Ayman were not allowed to work and Aya's siblings, Iman, Cedar, Muhammad and Ahmad, were unable to attend school. All the time, despite her unbreakable spirit and resilience, Aya's health deteriorated.

In June 2016, as part of the UNHCR's resettlement scheme, the family was relocated to France. Despite knowing the family for over three years, I realised on visiting them at their new home, that it was the first time I'd seen Aya's parents smile.

'Aya struggles to sleep,' explained Sihan, 'but on the first night I was able to say to her, "its ok Aya, this is your home now"'.

Tripoli, Lebanon. February 2016
Laval, France. June 2016

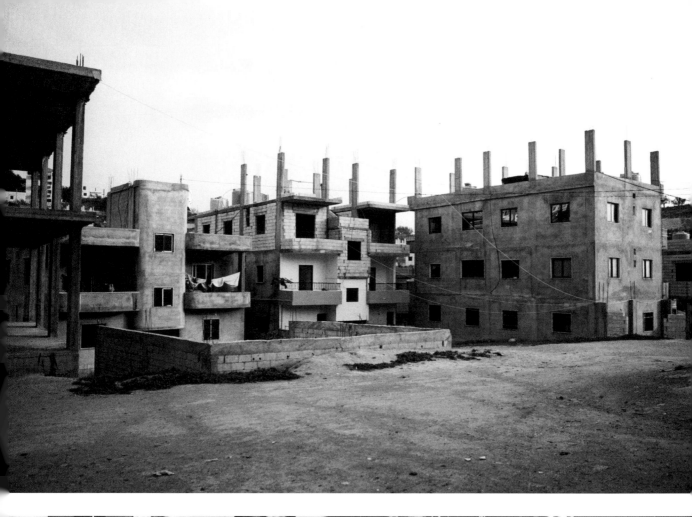

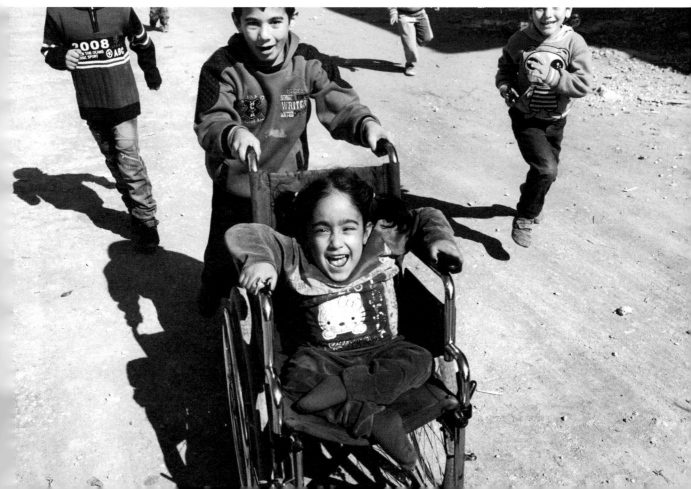

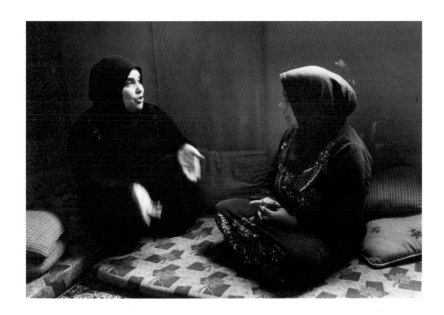

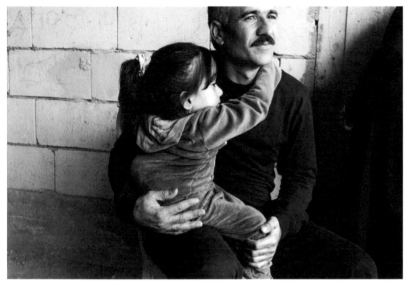

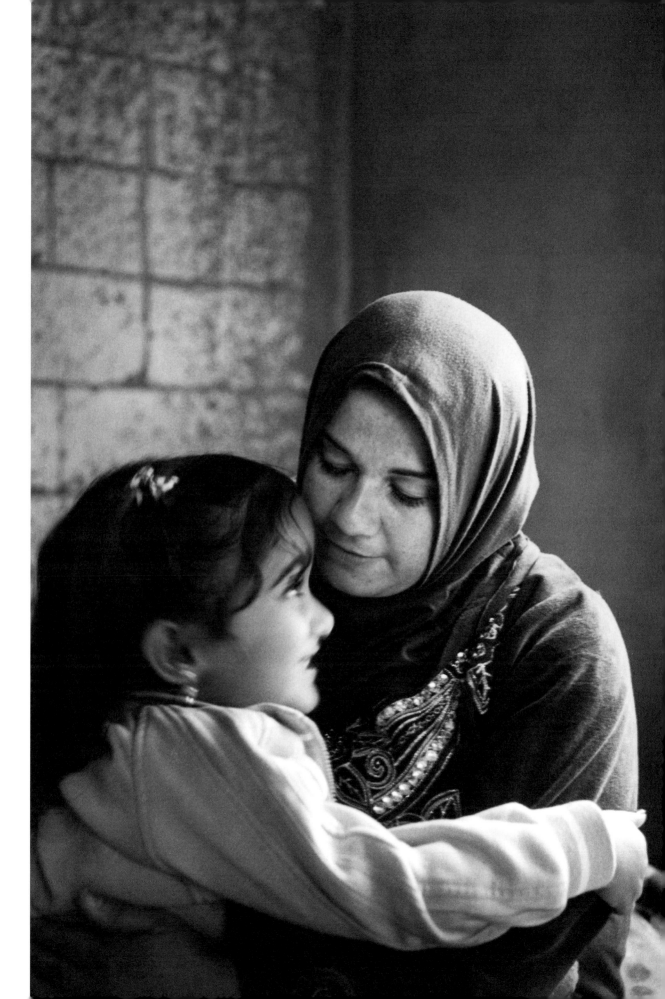

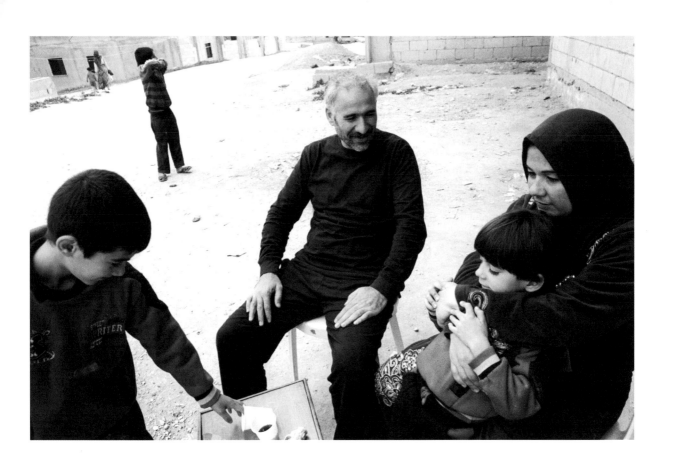

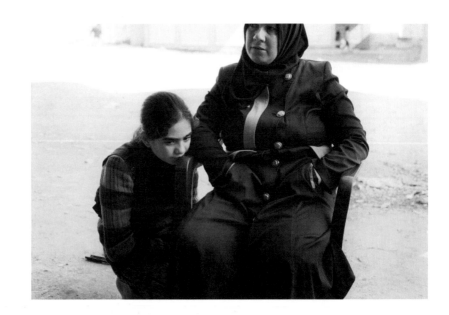

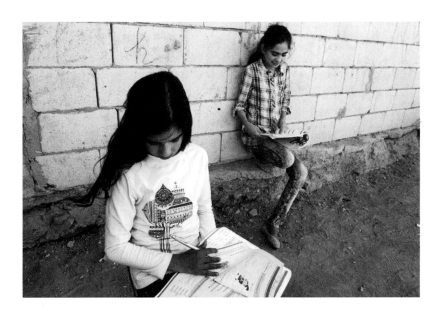

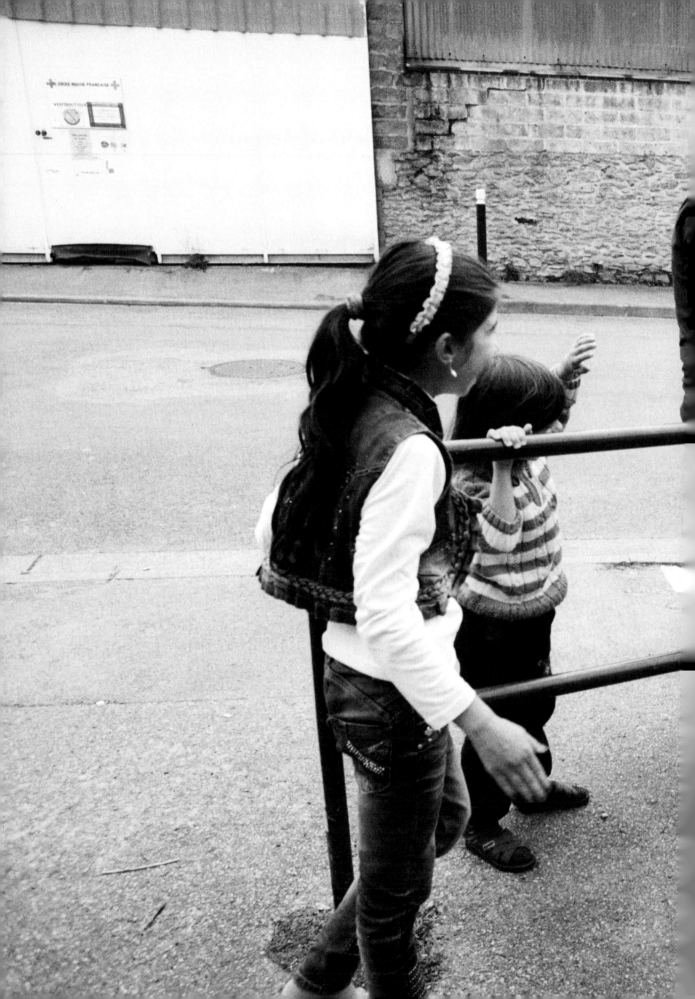

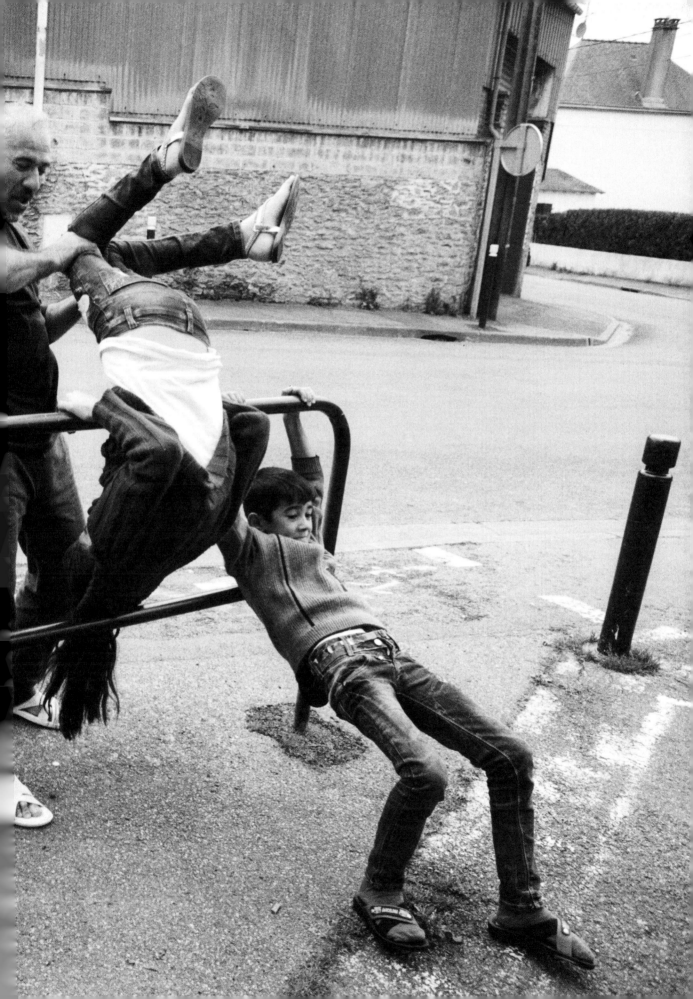

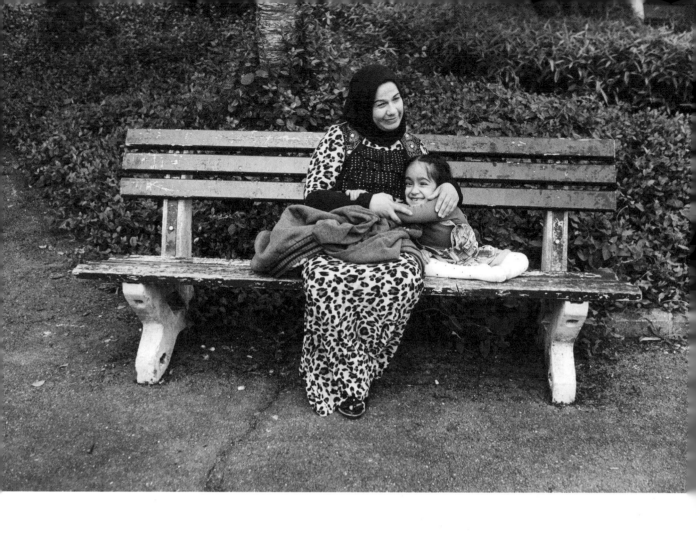

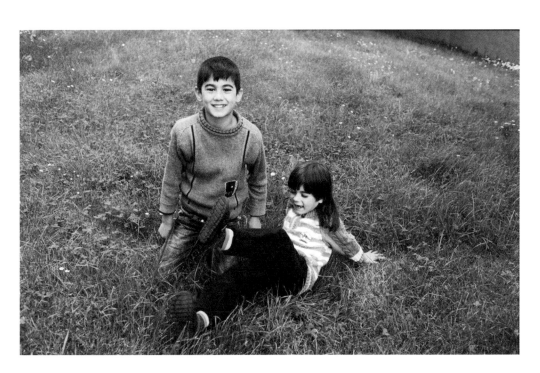

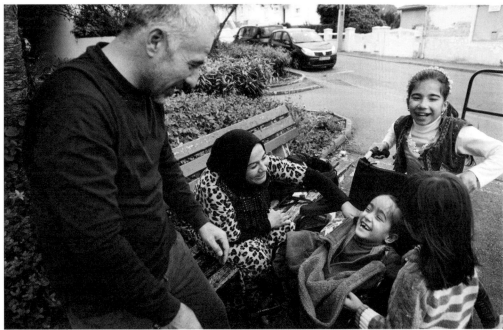

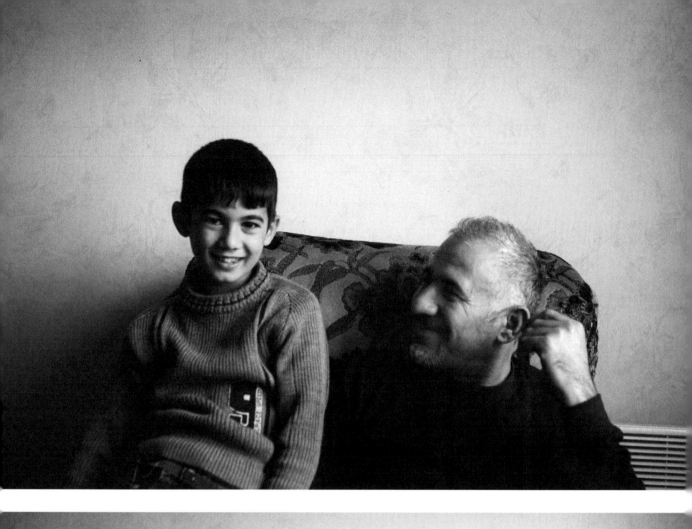

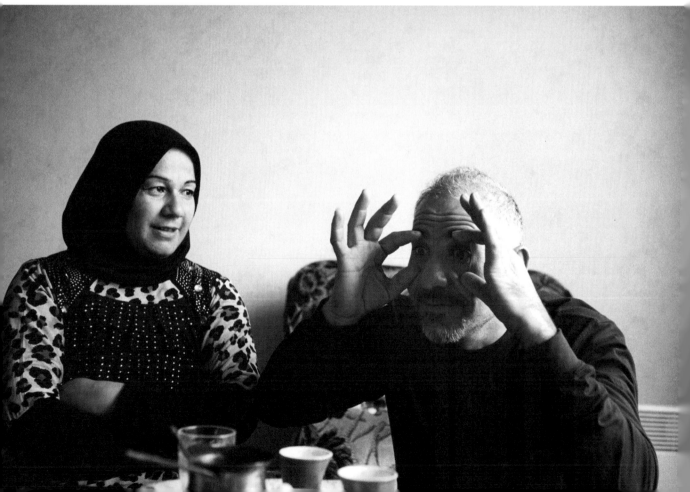

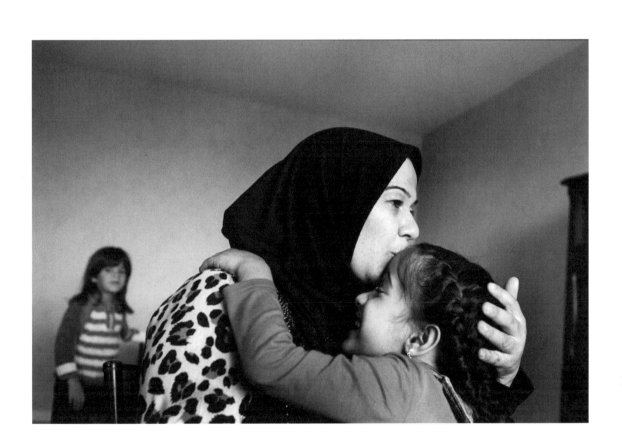

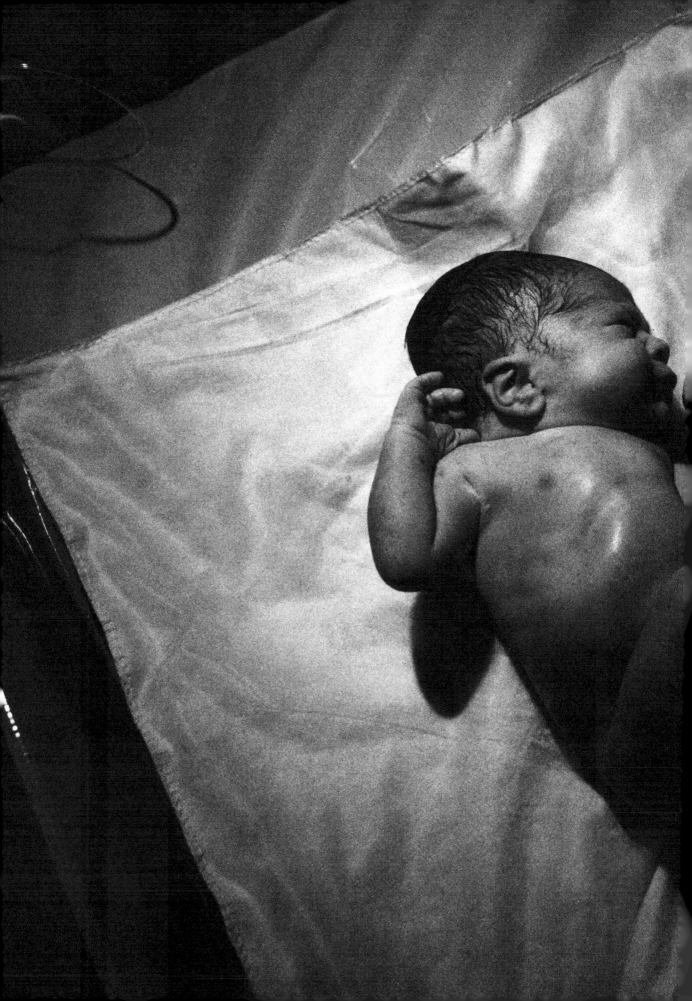

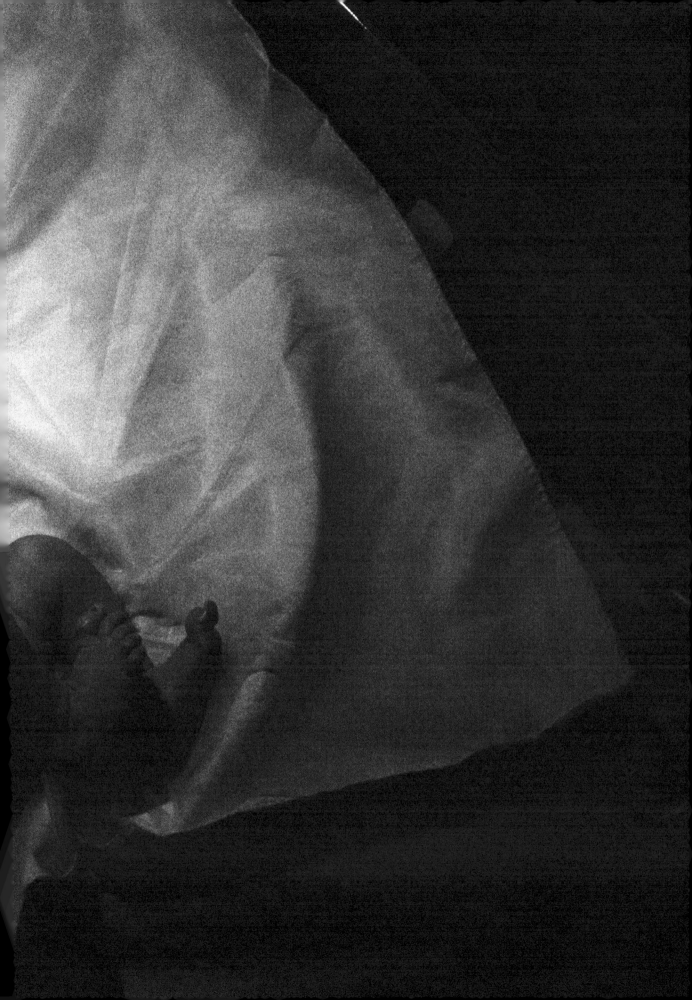

Acknowledgements

First and foremost, I'd like to thank all those who shared their stories with me for this book. I've always felt that the best photographs are not taken, but rather given; and that couldn't be truer than with this project.

When I first met Shamah, she was pretty angry. She came up to me shaking her finger, 'we don't want somebody taking our photograph; we need help.' And who could disagree with that sentiment? She had seen me arrive at the cluster of abandoned buildings that her extended family called home, near Mafraq in Jordan.

Shamah is over 90 years old and from Homs, a refugee in Jordan. Each day I returned to visit the families living there, and each day I chose to keep my camera in its bag. Over time she watched me work, and we built up trust. When I went back to visit for the last time, I put up my white sheet to start taking portraits, and without saying a word, she was first in line (her portrait is in Part III of the book).

Shamah allowing me to do her portrait was a beautiful gift. When I left, I said 'Goodbye Grandmother'. She smiled and told me I was precious. A beautiful lady, a day I'll long remember; the reason why photography is so special to me.

But Shamah is right. A photograph won't help her. This book won't help her. And we cannot rely on others to help Shamah and the millions of others like her, forced from their homes by violence and war. This is a global crisis, and a crisis that will only be solved with global effort. It is a time for each one of us to act in whatever capacity we can.

Do I believe a photograph can change the world? No. But I hope a photograph has the power to inspire the person who can. Only then will I have repaid Shamah's trust.

All profits obtained from the sale of this book will be donated to UNHCR, the UN Refugee Agency that protects the rights and well-being of refugees all over the world.

With huge thanks for your support and belief:
Melissa Fleming, Sybella Wilkes, Marjanna Bergman, Christopher Reardon, Jonathan Clayton, Edith Champagne, Suzy Hopper, Tessa Asamoah, Alex Court, Roshni Patel and all at UNHCR. Pia Holz Hansen. Edson Williams. Shaz Madani. Bathoul Ahmed, Ghazi Balkiz, Thekla 'the Egyptian' Kassivelidou, Ayman Al-Khalifa, Ghaith He, Patricia 'mother' Bou Nassif, Rasheed Hussein Rasheed, Susana Repaneli, Majd Massouh and Line Karout. The people of Nagu. Maria and everybody at Beyond. The whole team at Chan 'Hugs for free' Photographic. David Godwin and all at DGA. Lynn Gaspard and everybody at Saqi Books. Massive Attack. GQ. The Observer. C4. Leslie Knott, Achilleas Zavallis, Panagiota Tania Karas, Clementine Malpas.

Published 2017 by Saqi Books
First Edition

Images and text © Giles Duley/UNHCR 2017
www.gilesduley.com

Giles Duley has asserted his right under the Copyright, Designs and Patents Act, 1988, to be identified as the author of this work.

ISBN 978-0-86356-179-5

A full CIP record for this book is available from the British Library.

Designed by Shaz Madani

Printed and bound by GPS group in Bosnia and Herzegovina.

Saqi Books
26 Westbourne Grove
London W2 5RH
www.saqibooks.com

Sponsored by:

ILFORD PHOTO

LEGACY OF WAR

Chan Photographic Imaging

Previous spread:
Just seconds old, a baby born in Zaatari refugee camp.
Zaatari. 20 December 2015.